THE BRIDE'S GUIDE TO
Wedding Photography

HOW TO GET THE

WEDDING PHOTOGRAPHY

OF YOUR DREAMS

Kathleen Hawkins

AMHERST MEDIA, INC. ▪ BUFFALO, NY

Dedication

This book is dedicated to my knight in shining armor, my wonderful husband. Jeff, I want to thank you for being my best friend, my encourager and my strength. I could never have accomplished the things I have without your love and support. I do cherish you. I love you with all my heart and always will, from here to eternity!

Copyright © 2003 by Kathleen Hawkins
All rights reserved.

Front and back cover photos by Jeff Hawkins.

Published by:
Amherst Media, Inc.
P.O. Box 586
Buffalo, N.Y. 14226
Fax: 716-874-4508
www.AmherstMedia.com

Publisher: Craig Alesse
Senior Editor/Production Manager: Michelle Perkins
Assistant Editor: Barbara A. Lynch-Johnt
Editorial Assistance: Grace Smokowski

ISBN: 1-58428-094-8
Library of Congress Card Catalog Number: 2002113004

Printed in Korea.
10 9 8 7 6 5 4 3 2 1

Table of Contents

The biggest day of your life is about to arrive. Visualize the perfect flowers, a long, flowing dress and your prince charming waiting for the entrance of his beautiful, radiant bride. This is something you have most likely dreamt about since you were a little girl.

Hiring someone to document this important day is one of the most significant decisions you will face. (Well, that and, of course, who you will marry!) However, finding someone who can take the perfect pictures is only half of the dilemma. Arranging pre–wedding day meetings, choreographing wedding day details and selecting the post–wedding day products are all fine points to consider, though they are often overlooked.

This guide will help you find a photographer whose style and personality is

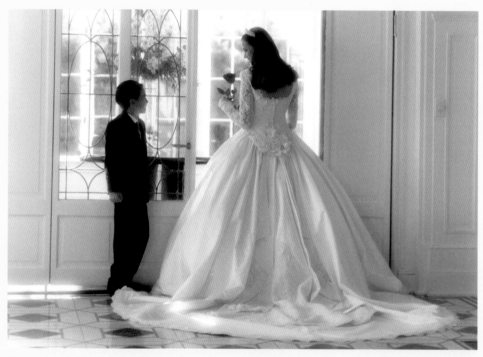

As you begin planning the details of your special day, take the time to educate yourself on all the important considerations that must go into hiring a qualified photographer. Photo by Andy Marcus.

the best match for you. After all, you will probably spend more time with the photographer than any other vendor; the limo driver, the caterer, the baker and the florist all come and go. The photographer will be there from the beginning to the end. It is important to follow your heart and have the peace of mind that you made the right decision.

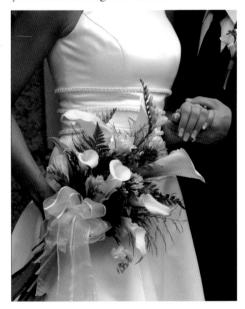

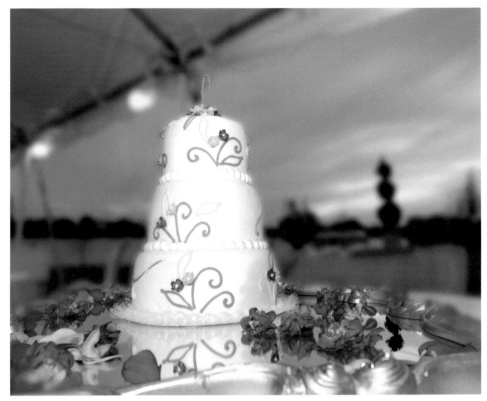

LEFT—Follow your heart and choose a wedding photographer who will capture the day the way you want to remember it. Photo by Deborah Lynn Ferro. ABOVE—In the end, your cake will be eaten, your guests will have gone home and your images will become your memory! Photo by Jeff Hawkins.

Y ou are getting married, and you have a lot to think about. There's the dress, the venue, the guests—and the photographer. You will need to find a talented artist to capture your emotions and document every detail of your perfect day. Since you can never reenact these important moments—the tears, the laughter, the joy—the endeavor to find the perfectly matched photographer must not be taken lightly. Finding this person is part serendipity and part hard work and research.

So, where do you begin this quest to capture your picture-perfect day? Where do you search to find a photographer whose style is appealing to you, whose personality meshes with yours and who offers the products and services that you desire?

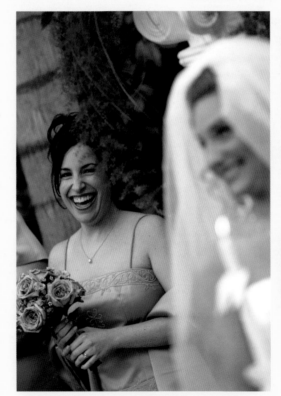

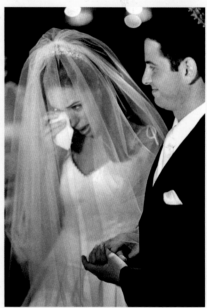

Whether it is laughter or tears of joy, the documentation of your emotions for the years to come makes your images priceless. Left photo by Ken Sklute. Photo above by Andy Marcus.

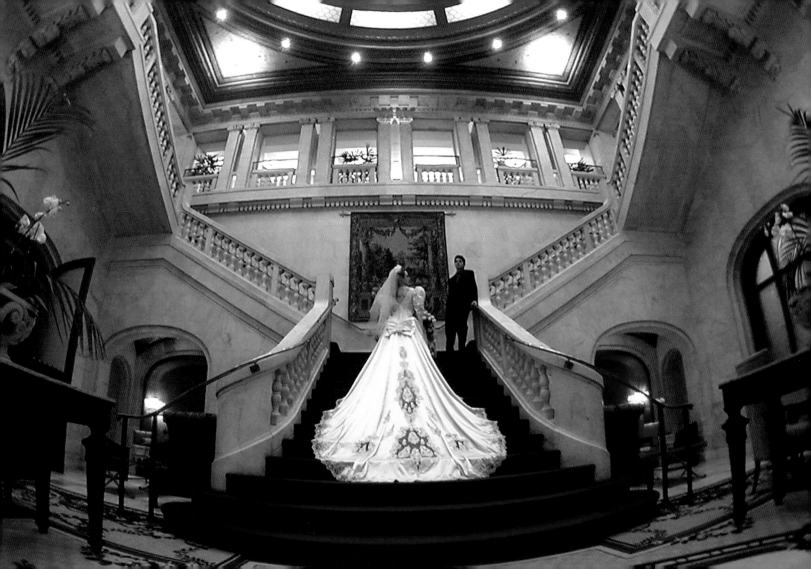

Traditional images are achieved by using formal posing and lighting techniques. Photo by Patrick Rice.

This book will guide you in selecting a photographer who's a perfect fit. You will learn how to locate a photographer who can produce the cutting-edge or time-honored, traditional images that you've always wanted. You will learn how to orchestrate a time line to ensure that the photographer gets all of those priceless images. You will read about retainers and contracts, and will discover how to create a color story that will make every aspect of your photographs work together in perfect harmony.

There are many things to consider when selecting the right photographer—it's not as easy as opening a phone book to hire a repairman—and it shouldn't be. The search may take some time. Typically, you should begin your search a minimum of eight to ten months prior to the special day. However, photographers Stewart and Susan Powers add this bit of caution: "You can never call too early to book your photographer, but you can certainly call too late."

○ TYPES OF PHOTOGRAPHERS

The first step in selecting a photographer is determining the style you like. Photographers typically fall into three general categories: traditional photographers, photojournalists and a photographer who blends both styles together. You will need to decide whether you want black & white images, color images or to have the session done digitally, in which case each image can be made either way.

Traditional Photographers. A traditional photographer creates a classic style of portraiture, one that is formal and posed. Over the years, certain guidelines have been established by top award-winning photographers working with this style. Now, younger generations of photographers use these "tried and true" techniques to produce images that appeal to a wide variety of clients.

Photojournalists. The photojournalistic movement in wedding photography is rooted in the documentary style of newspaper and media photojournalism.

Photojournalistic images are created with an outside-the-box mentality—formal rules are disregarded and special moments are captured as they unfold. Photo by Ken Sklute.

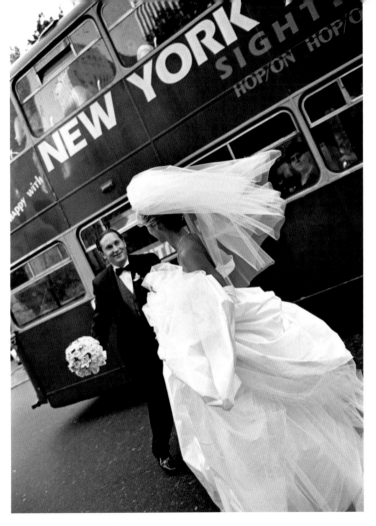

Photojournalistic images are commonly shot in black & white. Photo by Andy Marcus.

A photojournalist captures an event as it unfolds, rather then posing or staging the subjects. Because newspaper photojournalism is commonly shot in black & white, this style of coverage has led to a rebirth in the popularity of black & white wedding images.

Combination Photographers. To accommodate the vast number of variables involved in shooting a wedding and to satisfy the needs and desires of various clients, many photographers offer both the photojournalistic and traditional styles of coverage.

O AVENUES TO EXPLORE

Today, there are many incredible vehicles to assist you in your search. Web sites, bridal publications and bridal shows can be a good starting point, but the simplest way to find a great photographer is often through referrals.

Web Sites. By beginning your mission with a web site search, you can comfortably navigate the web sites of local pho-

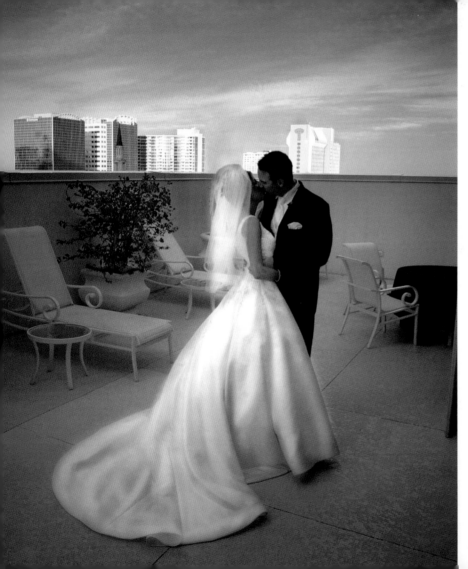

LEFT—Many photographers encourage couples to stand in a specific spot or to kiss, but then let their natural emotions flow into the photograph, blending photojournalism and traditional photography together for an appealing look. Photo by Jeff Hawkins. **BELOW**—By adding a creative angle to a traditional image, your photographer can create a fashion-inspired image. Photo by Andy Marcus.

Black & White Photography

According to Bill Hurter, editor of *Rangefinder* magazine and *WPPI Monthly* (the official publication of Wedding and Portrait Photographers International, an important professional organization for wedding photographers), "Black & white photography lends an air of timelessness to a wedding album and is consistent with photojournalistic style coverage. Without the distraction of color you are able to focus more on the feelings created by each moment." Many of today's couples prefer this style of photography. Nevertheless, many of the parents and family members believe black & white photography is going back a generation, instead of forward. So most successful and experienced photographers believe it is important to please all parties involved by providing both color and black & white images.

tographers and begin to unveil the style that is most appealing to you. Searching web sites tends to be a faster and more effective choice than going through the yellow pages since phone book ads do not typically feature the photographer's images. Web site navigation allows you to view the photographer's portfolio in the comfort of your own home. Follow these steps to begin your search:

1. Use a web search engine to find local photographers. Type in your city name and "wedding photographers" in the search field; for example, enter Orlando wedding photographers.

2. You will also want to do a search for local publications. The most helpful web site we have found is www.thepwg.com. At this site, you can register to receive a complimentary copy of *The Perfect Wedding Guide*. Because the site offers publications geared to meet the needs of brides from over fifty-seven locations throughout the United States and Canada, you can pretty much locate a vendor in any major city in the United States. If you visit a particular publication's web site, you are certain to find the web sites of established, experienced wedding photographers in your area who can afford advertising in wedding publications. In fact, this secondary search may help you to find photographers that you didn't catch with the first search. To be most effective in your navigation, select a site that is updated regularly and is professional and user-friendly.

3. Other helpful sites are:
www.theknot.com
www.weddingchannel.com
www.getawayweddings.com
www.wppinow.com
www.ppa.com.

4. Look for a web site that moves you emotionally and/or displays images that represent what you envision for your day. Once you find that site, contact the pho-

Web sites such as www.thepwg.com can be a valuable tool in locating your vendors.

tographer to determine his or her availability. Don't delay, dates fill quickly!

Magazines. Bridal magazines are designed to provide interesting and helpful articles about everything that has anything to do with weddings. They showcase the ads of many photographers (which can help you to define the style you are looking for), feature articles on a variety of topics and are chock-full of vendors' advertisements. Most national magazines include advertisements for photographers who are willing to travel and for studios that have multiple locations. While magazines will provide some great leads, there are some important facts to be aware of.

First, when a photographer is willing to travel, the bride and groom must typically incur the travel expense. You must decide whether or not the expense is justified based on your attachment to that photographer's work. Secondly, you will have to plan plenty of time for travel. Don't skimp on expenses like an extra night's hotel expense for your photographer because, in the event of a delayed plane or car trouble, this "savings" could cost you your wedding photographs. It is better to be safe than sorry.

Companies that have multiple locations advertised in national publications employ many photographers and will not showcase the work of every photographer—they will select the best images produced by that studio and display those images to increase sales. Therefore, it is important to request a local web site address so that you can review the work of the particular photographer who would be available to photograph your special day.

National magazines are a wonderful resource. Consider tearing out images that appeal to you and saving them to show to your photographer at the pre-wedding day consultation. Often, the photographer can recreate the pose or setup that appealed to you.

Local magazines—those geared to serve a specific region or city—can really be an excellent place to turn when looking for a photographer and other service providers. When reviewing the vendors in local magazines, you can rest assured that travel fees will not apply.

Advertising in magazines is often more costly than advertising in guides (see next page), so the images that appeal to you will likely be from a more upscale photographer. That could be good or bad for you, depending on your budget!

Bridal Guides. Guides are different from magazines. They tend to list categories of vendors, and within each category, you will find an alphabetical listing of professional caterers, photographers, etc. Guides are a wonderful resource—

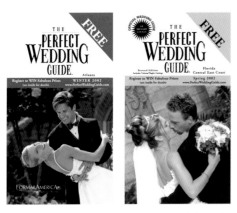

The Perfect Wedding Guide is just one of the publications that can make the planning of your wedding easier and more effective. Some guides are published to meet the needs of specific cities or regions. The Perfect Wedding Guide has over fifty-seven location-specific publications throughout the United States and Canada. Use the guide that caters to the area closest to you to reduce vendor travel fees.

they are both easy to use and readily available. You can think of a guide as a pocket-sized resource for finding professionals in the wedding industry.

Guides are generally more useful than the yellow pages because they strictly feature vendors that are interested in meeting *your* needs. You can find a wide range of images by various wedding photographers in a guide, without wading through pages of ads from photographers who actually specialize in children's portraiture.

A bridal guide can be extremely helpful in planning your event. Steve Saffar, the national publisher of *The Perfect Wedding Guide* and the web site www.thepwg.com, defines a guide as "the perfect source to plan everything for your wedding when looking for local wedding professionals" and "a one-stop source for all of the bride's needs." He adds, "If a bride is looking for a functional publication that offers her local resources, guidance from local experts in

her community and a portable publication that is convenient and easy to use, then *The Perfect Wedding Guide* is the perfect place to plan a bride's wedding."

Bridal Shows. As a bonus for advertisers, and to increase distribution, many guides and magazines promote bridal shows to both brides-to-be and the vendors in the community. This makes a bridal show a great place to connect with vendors (and, conversely, a great place for vendors to seek out new clients!).

In attending a bridal show, you can quickly view the work of many photographers in a single day. You will also have a chance to meet with many of these photographers. Photographer Doug Box believes it is important to get to know the photographer's personality. Doug says, "The photographer will be with you most of the day. It is important to like him or her. Some photographers are so nice you would invite them to your wedding, even if you didn't hire them. Others are wizards with the camera, but

are so obnoxious you can hardly stand to be near them. I feel a great personality with good photographic skills is more important than a genius with a camera and no bedside manners."

While bridal shows will provide you with the opportunity to meet prospective photographers, this is not the time to interview a photographer, get pricing information or make a decision. Typically, bridal shows are very busy and can be overwhelming. If attending a bridal show, make it your goal to achieve the following three objectives.

First, narrow down and select the top three photographers in attendance, based on the type of work they have displayed, their personality and level of professionalism. Do not take literature from vendors that are not in the top three. It will create confusion when you get home and want to follow up. Additionally, you will save vendors' money if you don't take marketing materials that you do not intend to use.

Next, when possible, determine if each particular photographer is available on your special day. Because dates are limited, you may want to have a backup date in mind. Remember that Fridays and Sundays are very popular for weddings today, and you may be able to save a little money if you book one of these days instead of a Saturday. Some photographers even offer a gift certificate toward products for clients who reschedule their wedding date to retain their service.

Finally, follow up as quickly as possible. Dates are limited; most photographers only photograph one function a day. Remember, at a bridal show, you are likely not the only person requesting information for the date you have selected. Do not go home with a bagful of literature and sit on it for two weeks before you follow up. If so, your date will most likely be booked by the time you get around to making the phone calls. Thus, attending the show becomes a waste of time!

Be certain to speak directly to the photographer who will be conducting your event to ensure that you both have the same vision. Photo by Susan Powers.

Referrals. Many photographers believe that the simplest way to find a photographer is through referrals. Photographer Andy Marcus suggests that brides talk with friends who have recently married. He believes they are the best source of information and will provide a base from which to proceed. However, photographers Stewart and Susan Powers offer a good suggestion as well, "Be aware that if you ask other people how much they invested in their photography, you may not get numbers that are accurate for your wedding." They recommend speaking directly to the photographer for a quote due to the very diverse and personal nature of weddings. After

RIGHT—Be certain to talk with friends who have recently been married. A happy bridal couple can provide a valuable referral. Photo by Andy Marcus. FACING PAGE—Consider asking your church to refer a photographer. They most likely have photography rules to abide by during the ceremony and may be partial to the professionalism of a particular photographer in your town. Photo by Douglas Allen Box.

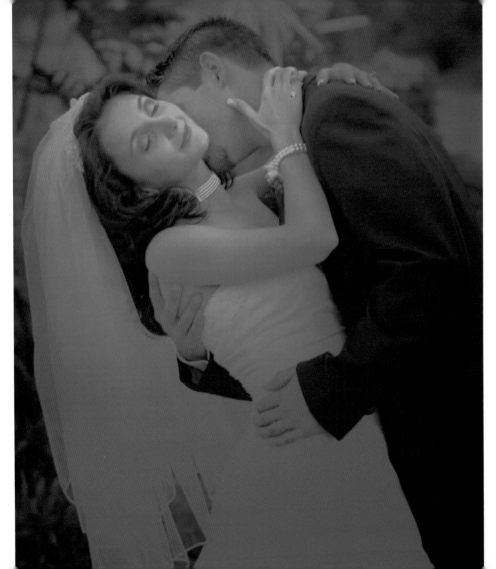

all, every wedding is the same, yet very different.

Another helpful hint is from photographer Doug Box, who recommends asking other vendors (florists, bakers, caterers, reception venues, consultants, etc.) for referrals. For the most part, Doug believes these people will be straight with the couple and give them useful information and suggestions. However, be wary of vendors who are being paid for referrals! In fact, you may wish to ask each vendor directly if they are getting paid for the referral.

Previous Clients. Finally, you can request a list of previous clients from the photographers. You may, however, receive mixed reactions to this request. Some photographers feel that distributing the names and phone numbers of past clients is an infringement of privacy. However, other photographers will distribute the lists freely. Photographer Jeff Hawkins believes that the best way to protect past clients' privacy while giving

potential clients access to clients' opinions is through the implementation of a "guest book" on the studio's web site. This way, photographers can encourage past clients to add an entry after their special day. He believes that this satisfies the needs of past and future clients both: couples get reviews on the photographer's performance and past clients can provide their contact information if they wish to rave (or complain) about their experience.

Serendipity is often defined as finding something or someone good accidentally. While luck or good fortune may play a part in finding the ideal person to document your special day, the task actually takes time and can be tedious. Beginning your search a year in advance will relieve some of the stress inherent in this endeavor. However, it is always impor-

tant to take advantage of the tools available to make your quest easier. Using the internet, bridal publications, bridal shows, etc., can assist you in locating the right photographer. Then you have to ask yourself, "Now that I have narrowed my search, what is the next step?"

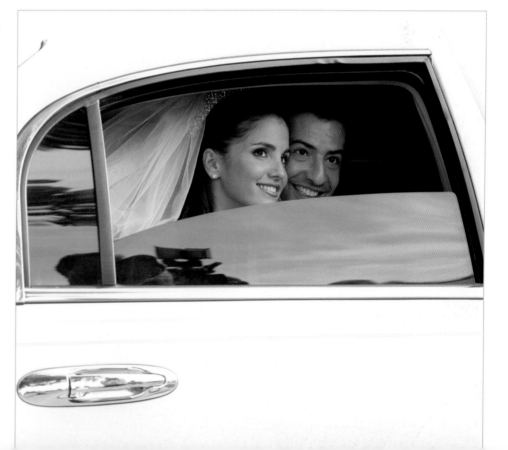

Begin planning for your wedding day a year or more in advance to eliminate as much stress as possible. Facing page photo by Jeff Hawkins. Right photo by Andy Marcus.

2. The Selection

The search for a photographer can be a very educational process. Though bridal guides and magazines are helpful, feature articles are sometimes written by people outside of the photography industry. Furthermore, many times articles are recycled—in other words, they appeared in an earlier issue and are simply pulled out of the archives, updated and tweaked year after year. Because many aspects of wedding photography—like time lines, prices, etc.—may vary, these updates may not reflect what's going on in your area.

○ THE CONSULTATION

This is where the consultation comes in. During the consultation you can expect to learn about pricing, procedures and more. Again, each photographer's prices, time lines, etc., may be different; for this reason, it is important to book a consultation with more than one photographer. Doing so will help you find a photographer who is a good match, as well as

A formal bridal session or engagement session can serve as a trial run and help establish a comfortable rapport. Photos by Jeff Hawkins.

develop a realistic budget and solidify important paperwork.

Personality. Remember that you will be spending a lot of time with your pho-

tographer—you will want to make sure that he or she is someone you trust and are comfortable with. Photographer Jeff Hawkins says, "If the personality does not mesh well, it will show in the photographs." He suggests doing a trial run with an engagement session or formal bridal session.

If you are considering a studio that employs several photographers, make sure you actually meet with the photographer who will be covering your event prior to signing a contract.

Photographer Doug Box encourages each couple not only to meet with the photographer but to view a couple of the wedding albums he or she has created as well. He mentions that anyone can get a couple of great images at a wedding, but you want to see what the photographer can do with the entire wedding day.

It is also important to make sure the person you hire has extensive experience in the wedding industry. Just because someone is a great portrait photographer, newspaper journalist or commercial photographer does not mean he or she can photograph a wedding!

Act with caution before hiring Uncle Joe, a commercial photographer from another state who promises to save you a bundle. Bad wedding photos are never a bargain. Follow your heart and trust your intuition. If the situation feels right, it probably is!

Budget. Although budget is important, when scheduling a consultation, many couples' first impulse is to call and ask for photographers' package prices. Most quality photographers become frustrated by pricing inquiries—especially if the couple has never viewed their work. A price range can be helpful; however, there are usually a variety of factors involved with customizing prices for each couple. Phone shopping can be very costly to the couple.

Costly Mistakes. Do not "shop price" over the phone when searching for a photographer. There are many things

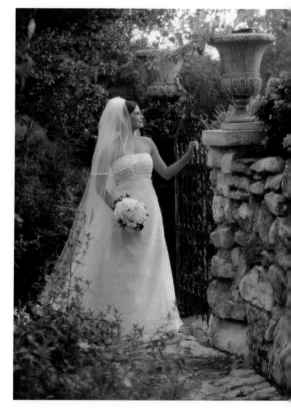

Working together before the big day will help ease your mind and solidify your decision. Photo by Douglas Allen Box.

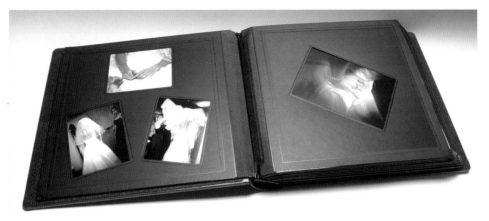

There are many different album styles and options. Always view your album choices before your event. Album by Jeff Hawkins.

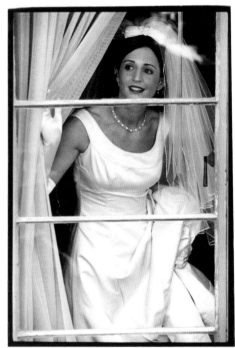

Storytelling albums show how the day unfolded. These images showcase the emotions of all the important players in the wedding. With this type of photography all of the details are documented—from anxiety before the ceremony to joy at the reception. Above and facing page photos by Ken Sklute.

that go into pricing, and these may not be apparent in that price quote.

First, you may never get to see the endless image possibilities available to you if you begin shopping for a photographer with a particular price in mind. Remember that optional products, the style of coverage and the amount of images will affect the final cost.

Second, both album styles and album quality affect pricing. Storytelling albums (also known as "love story" albums) showcase the close relationships between people in attendance at the wedding. In these albums, photographers use emotion-filled images to tell the story of how the couple's day unfolded. While less expensive, formal albums feature only a few traditional, posed images; however, these specialty albums are more involved. If a package includes one of these albums, your costs will be higher. For

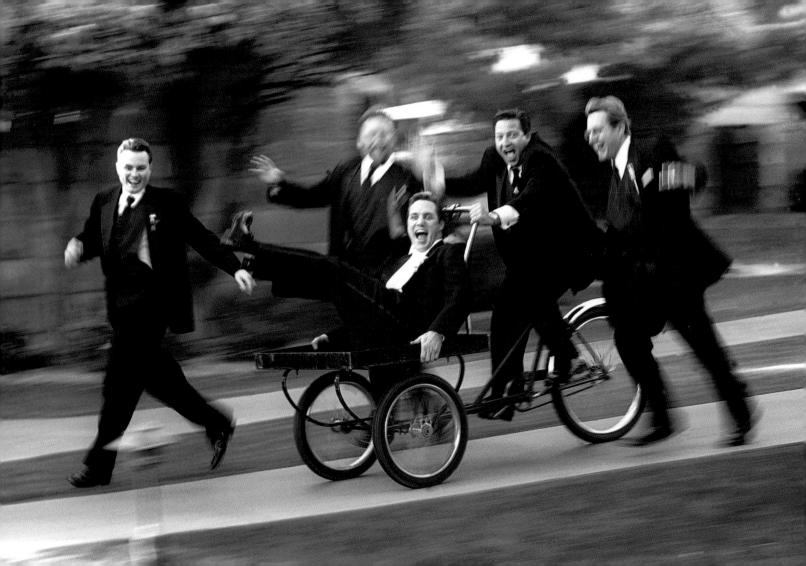

many, these albums are well worth the added expense.

Finally, if you only consider price when shopping for a photographer, you may end up hiring a freelancer or an associate. You may discover that the old cliché "you get what you pay for" is true!

Of course, hiring a lower budget photographer is not always poor decision. If cost is a primary issue, consider consulting with a photographer whose prices are on the low end. Review the photographer's portfolio style and meet with him or her personally. Do the same with a photographer whose prices are in the midrange and one whose prices are on the high end. If you don't see an obvious difference in the style of work and the quality of printing, images and albums *or* the photographers' level of professionalism, it may be best for you to hire someone in the mid- or lower-price range. Don't base your decision solely on the amount of pictures or products you will be get-

LEFT—Remember, once the cake is eaten and the flowers die, your photographs become a priceless heirloom. Photo by Jeff Hawkins. **RIGHT**—When you purchase an album, you are purchasing the photographer's vision and expertise. Photo by Ken Sklute.

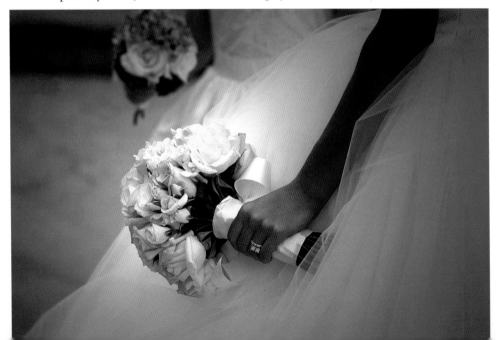

ting. Keep in mind, as photographer Ken Sklute mentions, "What you are purchasing is the photographer's vision and expertise, the current style or technique, or even the best equipment." It is crucial to realize, once the cake is eaten, the flowers die and the day is over, the only thing remaining is the photographs. Images are never expensive, they are priceless!

After you find the perfect photographer, you may want to reconstruct your budget. It is amazing how much money couples allocate for food and flowers and how little they budget for photography. The rule of thumb is that 10 to 15 percent of your total wedding budget should be earmarked for photography. That percentage will fluctuate based on a couple of factors, like how big of a picture person you are and how important photography is to you. Remember that in the end, you will pass your album on to future generations. Photographers Stewart and Susan Powers point out that,

If your vision closely matches that of the photographer, you will most likely be pleased with your photographs. If the visions are different, keep searching until you find a match! Photo by Jeff Hawkins.

"The wedding photographs may be the only item from your wedding day that will increase in value. When you are shopping for photographers it may help you to remember that the best quality and service will never be the best in price. Generally, you do get what you pay for."

The Best Scenario. A bride and her mother sit down to create a wedding budget. The mother got married twenty-

five years ago and remembers paying $250 for her photographer. She received an album with eighteen posed 8x10-inch images. Assuming that the price of photography has increased in the past twenty-five years, and reviewing the basic pricing in the magazines, the mother budgets $1000 for photography.

Next, with the budget and her busy schedule in mind, the bride contacts a few studios and inquires about their package prices. After many phone calls, she narrows the selection down to three photographers. The mother and daughter visit those studios for consultations.

○ THE RETAINER

Your head is spinning. You've narrowed your options down to one photographer who seems to suit your needs. You have reviewed the work and like the style and personality of the photographer in question. You have asked every question you could come up with and feel comfortable with the answers you received. You now

The Interview

Have you found a photographer who's a perfect fit? The work is stunning, the personalities don't clash and the budget seems workable—what now? Do you complete the paperwork and move on?

This is where the interview comes in. An interview is an extension of the consultation, and it is often done on the same day. In an interview, you can cover anything that you'd like to discuss to ensure that you're about to make the right choice in choosing this particular photographer.

To help you make the best decision, a selection of wedding photographers from across the United States were surveyed and asked, "What do you feel is the most important question for a bridal couple to ask in an interview?" The most common responses were as follows:

1. Couples should ask what the photographer thinks is important about wedding photography. They should also have the photographer describe a perfect bride or a perfect wedding.

The reason is simple—if the two visions are the same, then the style is a match. If they are not, you will need to continue searching.

2. The bridal couple should ask whether a studio sells a service via a package or à la carte. They should have a good understanding of what specifically they will receive for their investment, like how many hours of coverage are included in the specified price.

3. Who will be photographing the event? Make sure the person whose images are showcased is the person covering your wedding. Everyone's style is different, so this is important.

4. Do you have backup equipment and supplemental lighting? This is important; a camera that crashes during the ceremony could wreak havoc and a photographer that keeps turning up the lights at a reception can ruin the ambience.

5. Will there be a film limit? Does the photographer's service include black & white as well as color images? What is the average number of images captured?

6. Why do you photograph weddings? (This will reveal the photographer's level of passion and excitement.)

7. What percentage of your business is wedding photography? (Most well-known established wedding photographers in the photography industry state that about 75–80 percent of their business is wedding related, where only 20–25 percent of their business is portraiture.)

8. How much time do we need to allocate for our formal portraits?

9. Are engagement sessions included in the pricing level described?

10. Will you be working alone or will you have an assistant?

11. What is the required deposit?

12. When is the balance due?

13. What types of albums do you offer?

14. What product guarantees do you provide to protect our family heirloom?

Of course, there are also interview questions that photographers hate to hear:

1. How much does it cost? Typically, when this question is asked photographers cringe and become very defensive. With a quality photographer, it is not because they have anything to hide, but because they cherish their work and are protective of their images. Asking any photographer this question before viewing a portfolio and expressing appreciation for their work devalues their time, passion and creativity. Decide first if this is the style you desire and then discuss the bottom line. If your budget is tight, simply let her know your concerns and task them to give you a basic price range up front.

2. What type of equipment do you use? If you ask an experienced photographer about their equipment they will probably (you guessed it!) cringe and become very defensive. Bridal publications often encourage you to ask this question because, indirectly, the type of equipment being used typically determines how qualified the photographer is. Nonetheless, professional photographers dislike being bothered with this question, because most of the time the person asking it doesn't fully understand the response the photographer would give. Photographers know that while equipment codes and industry jargon might sound impressive, they will also confuse a prospective client. Asking a professional photographer about his equipment would be like asking a surgeon what kind of instruments they will use when they operate.

To determine a photographer's qualifications, review their recent wedding image samples, talk to past clients and get references from people within the community and wedding industry. Rather than asking what type of equipment they use, just make sure they carry backup equipment and produce a wide range of quality images from 4x5 inches to 30x40 inches.

After all, if you like the final results, does it really matter how the image was captured? Pay your photographer to worry about image quality so you don't have to.

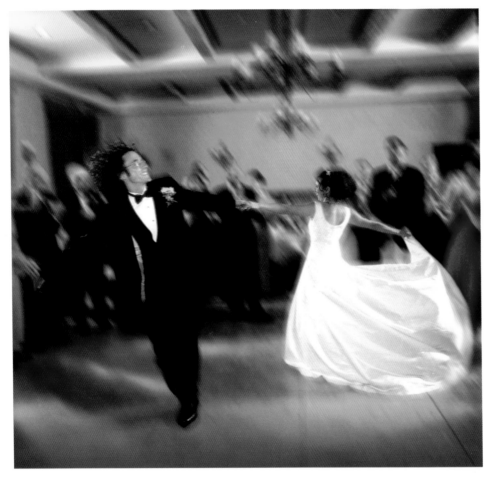

To capture images like this one, your photographer must own and bring supplemental lighting and backup equipment. Photo by Ken Sklute.

have two options: you can sign the contract, place the retainer and have one less decision to make in regards to your special day or you can take the information home, review it, re-examine your budget and make a decision later.

Well, let's step back a minute. Did you bring everyone involved in the hiring decision to the consultation? Most people are very busy and do not have time for multiple appointments. If you need an opinion from your fiancé, family members or friends, bring them along to the initial consultation. It is easier to make good decisions when everyone involved—and the products involved—are all in the same place. Describing ways to modify packages and services to someone who can't see what you're talking about is frustrating at best—especially if the consultation was an educational yet overwhelming experience for you! Two

(or more) heads are always better than one.

Once you feel good and are at peace with your selection, book the photographer immediately! Do not procrastinate. Dates book up very quickly and many bridal couples have lost their first-choice photographer because they had to take information home to discuss it with a parent or partner. Place the retainer or deposit and begin completing the required paperwork. Book your photographer nine months to a year in advance. As soon as you set your wedding date, begin searching for a location and retain the services of your photographer. Locations and photographers both book quickly since available dates and times are limited, so don't delay!

Retainers and deposits are viewed differently in every studio. Make sure you fully understand the studio's requirements and policies. Whether the studio refers to the downpayment as a retainer or a deposit, the bottom line is you are paying a fee to reserve the date and engage the photographer's services to cover your event.

Before placing your deposit, find out if it is refundable in the event that your event is cancelled or postponed. Most photographers surveyed collect a nonrefundable date reservation fee. This fee covers the time spent completing paperwork and coordinating time lines and conducting pre-wedding engagement or formal sessions. It also offsets potential lost revenue if the date is not rebooked. In this time of blissful love the last thing on your mind is cancelling or postponing your special day. However, it is better to be safe than sorry. After all, life is never predictable!

○ THE CONTRACT

Before you turn over the retainer, review and solidify the paperwork. Be especially wary of studios that do not have professionally printed contracts. Characteristically, that implies one of two things: they are not experienced in weddings or wedding coverage is not their specialty. Determine what percentage of the studio's business is wedding related and, no matter what, require everything in writing. Unfortunately, your photographer's word is not good enough. You need documentation for protection in the event that something goes wrong. Without it, you cannot make the photographer accountable. Below are the considerations that should be included in your wedding contract.

Name and Contact Information. The contract should include the names of and contact information for both parties. Make sure that your contract specifies the name of the photographer who will be covering your event—not just the name of the studio. Read the fine print for a replacement or substitute photographer clause.

Complete Date and Coverage Time. Be sure that the start and end times are clearly spelled out. If this changes be-

tween the initial contract signing and the wedding date, it is the bridal couple's responsibility to ensure that the date and/or time portion of the contract is modified in writing. Do not make adjustments over the phone. It adds to confusion and, legally, the photographer is only obligated to follow the specified (written) contract times.

Itemized Prices. Make sure that the fees for each component of the photography service are clearly itemized. The list should include prices for products as well. This is important because, when you are booking a year or more in advance, prices will often change. If you adhere to the time constraints imposed, any price increase should be absorbed by the photographer.

When planning to photograph formal portraits after the ceremony, time management is a real concern. Setting up a time line can help ensure that everything runs smoothly. Be sure to discuss this with your photographer prior to the big day. Photo by Ken Sklute.

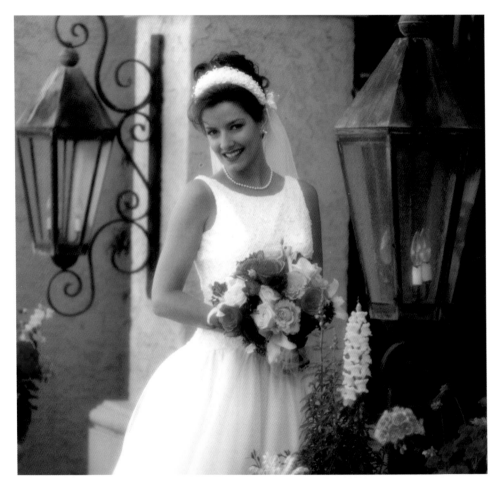

Payment Policies and Cancellation Clauses. Make certain you understand when payments are due and what the policy is not only if you cancel, but also if the photographer cancels your contract. Can you be bumped for a bigger, more profitable wedding?

Hidden Charges. Search the contract (especially the fine print) for hidden charges such as contractual modification charges or overtime fees.

Film Limits. Make sure that the contract covers the minimum/maximum number of black & white and/or color film images the photographer will take.

Proof Policies. Be sure to find out what type of proofs you will receive, and approximately how many proofs you will review. Weddings are uncontrollable events and every wedding varies greatly depending on the type of function, the number of guests and the pulse of the party. Understand that the absolute number of proofs that will be created is an unknown, but the photographer should be able to provide an estimate based on the particulars of your wedding. Also, be sure that you understand when you will get your proofs, how you will receive your proofs and how long you will get to keep them.

Product Pricing Clauses. How long after the wedding will prices be secure? How long after the wedding can orders be placed?

Album Order Guidelines. Understand time restrictions for placing album orders. Often couples are penalized for procrastinating. If you take an extended honeymoon, will you be subject to higher prices upon your return? Make sure design time limits are placed in writing. Also, be sure that the contract contains the estimated album completion time frame in writing. If you pay for product up front, it is important to have documentation that you've done so as well—in case the album is still incomplete six months to a year or more after your special day and legal representation is required. Some photographers, mostly unprofessional or inexperienced ones, mismanage their funds and find they do not have the money to order the product, thus creating a delay. If you have a time frame in writing, however, you are most likely not dealing with a culprit of this financial juggling.

File Ownership. Copyright guidelines and negative policies should be disclosed in the contract. Understand who owns your file and your images. This area of the law can be tricky and is often misunderstood. While the bridal couple is paying for a studio/photographer to capture their event and create images for them, once an image is created it is actually copyrighted to the photographer. Clients pay for the creation of the image and the final product, but do not typically pay for the copyright release of the final product. Thus, copying or reproducing the images in any form is prohibited under federal copyright laws and is strictly enforced. With scanners and

image copiers easily accessible to clients, more photographers are processing violations and national organizations are assisting them in this endeavor. Infringement of these laws can be extremely costly—copying photographs

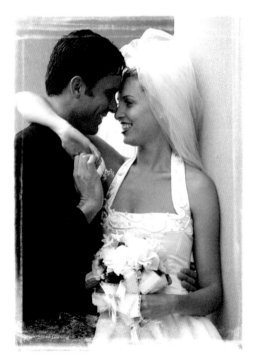

illegally is definitely not worth any potential savings. Find out how long the photographer will keep possession of your negatives and how much they charge for the copyright release of your images.

Model Releases. As specified above, the photographer owns the copyright of the image. However, the law protects the couple as well. Before a photographer can showcase images from your event, they have to receive a written and signed model release. This release should list in detail where the work may be showcased; for example, in studio displays, advertising, on a web site and for instructional or institutional purposes with the highest standards of taste and judgment. If applicable, it should also state whether or not photographs of guests are subject to the

aforementioned uses and should be so advised by the client. The model release is only valid if signed by the said client.

Once you have reviewed the required documentation and covered each of the above considerations, it is most likely safe to sign on the dotted line. Be sure to make a copy of the contract for your files so you can review it as your wedding day approaches.

Although all you can think about is the love you feel and the excitement over your upcoming wedding day, getting all of the important details in order is a must! Don't forget to inquire about cancellation fees and any additional expenses or penalties. Left photo by Deborah Lynn Ferro. Facing page photo by Barbara Rice.

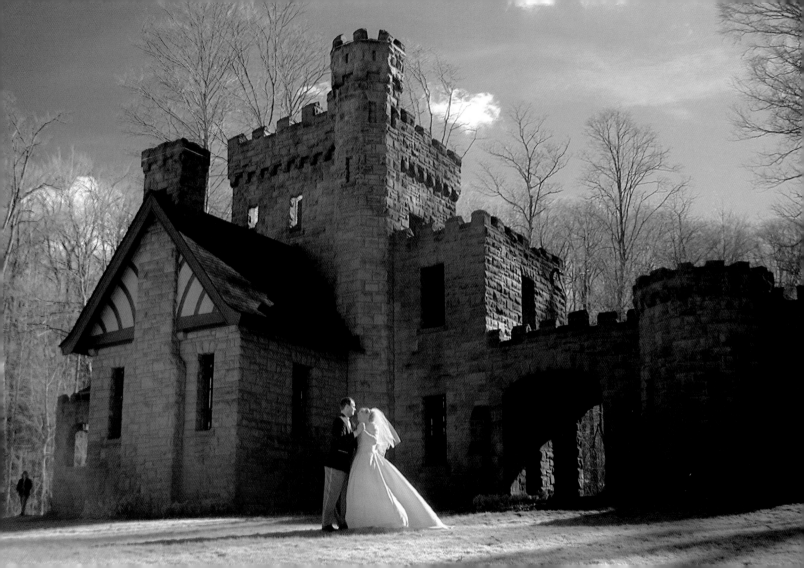

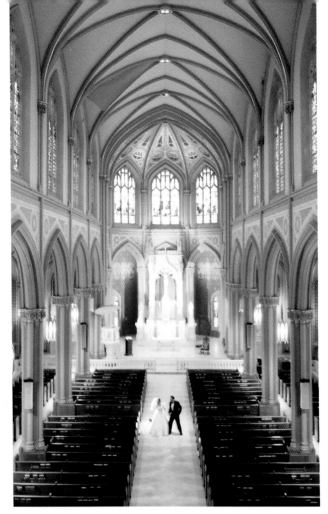

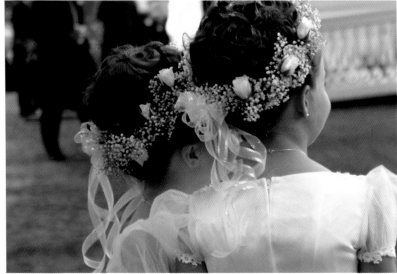

Copyright guidelines and negative policies should be disclosed in the contract. Understand who owns your file and your images. Left photo by Patrick Rice. Above photo by Susan Powers.

A lot of time and energy goes into the creation of a picture-perfect wedding. Photographs are tangible memories, records of the emotions shared on your special day. Many of the important decisions you make—from your dress and veil to the wedding party attire to makeup to the type of exit you'll select to the décor at your reception— will either positively or negatively affect the outcome of your images.

O APPEARANCE

It is important to consider the color harmony of the dresses, flowers and makeup of any of the key players, as all of these variables can make or break an image. It is also important to consider the figures of the bridal party when selecting bridal attire. One of the most effective ways to ensure a great, cohesive look is to pick out a material and color theme you prefer and allowing the bridal party to pick out styles that flatter their figures. (This preference also often extends to parents and family members.) These matching gowns look great in photographs and make the party feel comfortable in the style they are wearing!

Recently, a photographer shot a wedding where the bride selected a beautiful taupe shade for the bridal party to wear. The mothers were instructed to wear a cream or beige color. The sister of the groom (who was not asked to be in the bridal party) was then added to the family portrait, and because she was wearing

Your own appearance isn't the only thing to consider when planning for wedding photographs. Discuss color harmony with your close relatives and bridal party attendants, or leave it to an expert. Photo by Jeff Hawkins.

a bold, deep-purple dress, she did not look like an important member of the portrait. Be certain to include step-

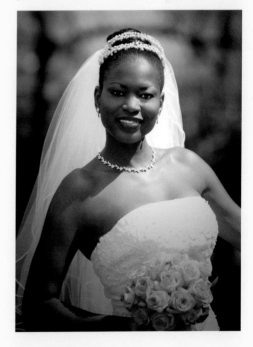

parents and siblings in this effort. It will make them feel included and will improve your images, too.

Makeup is a tricky subject. Find a professional who has lots of experience with wedding makeup so you don't end up looking washed out or overly made up. Selection and application is best left to a professional makeup artist who can analyze your skin tone and how your makeup works with your flowers, your bridal party's attire and the room décor.

Formal pre-wedding images will help you to see how everything looks prior to the big day. When you see these images, you can determine whether any changes need to be made to your appearance. For more information on formal portraits, see chapter 4.

○ EXITS

The wedding day is coming to a close, and your big exit is fast approaching. Most locations do not encourage receiving lines or the throwing of rice, so how

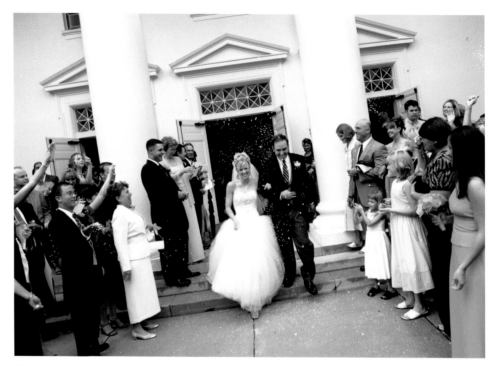

The big exit is a fun part of the wedding and an important shot in many albums. Above photo by Jeff Hawkins. Facing page photo by Stewart Powers.

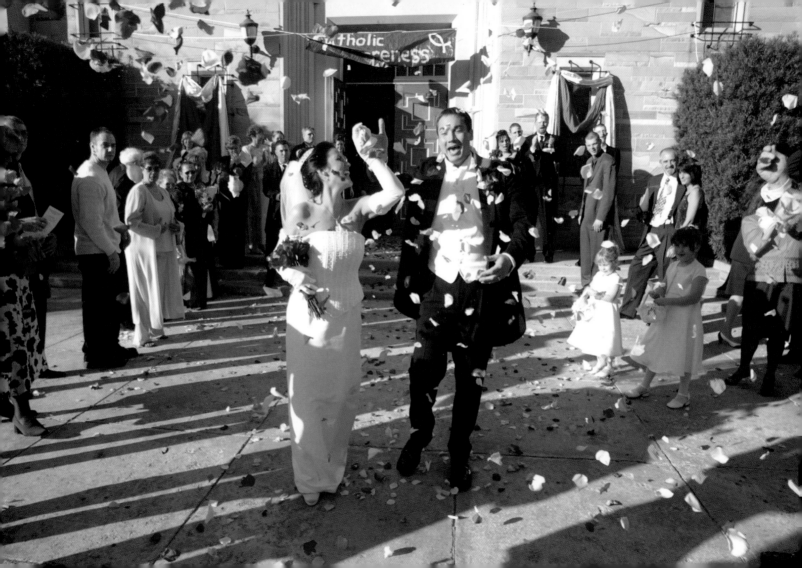

do you make your exit? Commonly, you and the groom will not make two grand exits on the same day. Instead, you will need to determine which location is more appropriate for the big exit—the site of the ceremony or the reception hall.

Even with the use of private time (discussed in chapter 4), normally there are some formal photographs that must be captured after the ceremony. Therefore, most couples elect to have their big exit after the reception as long as their photographer is scheduled to stay until the conclusion of the event. Regardless of when it is done the most common exit props used today are streamers, bubbles, butterflies, bells, doves, rose petals, candles, organic rice and confetti.

Exits are important in storytelling photography. They serve as scene setters that conclude the ceremony chapter and the end of the album. Photographer Doug Box adds, "All of the exits can be effective and make for fun photographs. However, the bride and groom should consult the photographer ahead of time to get the photographer's suggestions on how to capture these special moments and orchestrate the event. Recently, a bride had a small container of bubbles on the seat for each person with a note to blow the bubbles as the bride and groom excited the ceremony. (It was an outdoor ceremony.) Only two or three people did

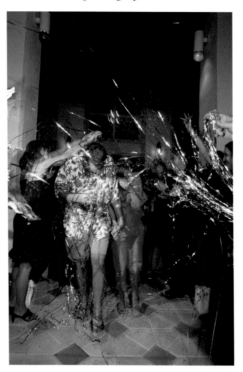

Whether it's with bubbles or streamers, be sure to coordinate your exit with your photographer. Above photo by Deborah Lynn Ferro. Right photo by Stewart Powers.

as she requested." Doug mentioned that if she had discussed this with him, he would have suggested assigning people ahead of time to inform the guests about the plan. He recommends having the pastor or the justice of the peace make an announcement after the kiss, as this can lead to better prepared guests.

Photographer Patrick Rice points out that church exits can be tricky. He suggests being realistic with your exit expectations and coordinating with your photographer to make the best transition.

No matter how you plan your exit, however, it should be exciting! Here are some ideas:

- Doves have great symbolism and impact, but use more than two for the ultimate images.
- Streamers can block the view of the photographer when he or she is photographing the bride and groom. Make sure everyone has plenty of room to move!

Receiving Lines

Receiving lines have become passé because they are time-consuming and, coupled with the formal portraits, it lengthens the amount of time away from the guests.

- Sparklers have become popular but you have to consider the possibilities of damage to the dress and the amount of smoke they generate.
- Butterflies rarely fly simultaneously, so the supposed "Wow!" finish often becomes a series of smaller "Ahs. . . ." They are best used for outdoor ceremonies.
- Bells and candles can be cute, but they don't necessarily add a lot of oomph to your images.
- Organic rice is great for photographs, but be prepared—you will be a sticky mess by the time you get back to your hotel room!
- When coordinated correctly, bubbles and rose petals are usually the most photogenic!

Whichever type of exit you select, know that it will become an intricate part of your story line. Like many other photographers, photographers Stewart and Susan Powers believe, "Exits are vital to the story, so they [the bride and groom] prepare for them as much as possible. Each bride has a different idea for her exit. Some are grand, some are fast and some are furious!" They suggest you inform your photographer of your plans ahead of time so he or she can prepare with fresh batteries, new flash cards and the right lens and be ready to go when you are! An exit image will help define the sequence of the event.

Photographer Andy Marcus explains that using exit images in the album can help to visually convey a good story and

the specialness of the day. Exit images help to create a rhythm, a time line—and help to create a more valuable album.

When conceptualizing the décor for the reception, consider the fact that many photographs will be taken in the room. To ensure great images, consider color harmony of the décor and lighting. Magical hues can be created by the decorator, the lighting technicians and often even the photographer. Different colored gels and filters can alter the ambience of the event. Lighting can be added to the walls, the dance floor or the décor by the lighting technicians or even decorators— or a colored gel can be added to an external flash to create interesting backgrounds by your photographer. Pink and blue hues can add a mystical touch to your atmosphere, while brighter, bolder colors can pump up the party as the evening progresses. Consult with a professional to ensure the color is lighting up the appropriate areas and not washing out your skin tones! Your lighting effects can be dramatic or subtle, depending on your budget. However, simply using special lighting for the main events like the first dance or the toast can add excitement to your wedding day and creativity to your images!

Once the images are captured, there are many ways in which they can be used at the reception. Some couples purchase signature frames, which can be autographed by guests. Many couples use image reflection displays—a slide show of continuously-running images from the wedding day. If any of these options are important to you, you'll need to discuss them with your photographer and make arrangements for their use when you plan your reception. Additionally, if your photographer offers online ordering through his or her web site, you'll need to place order-instruction cards at each guest's place setting. For more information on these topics, see chapter 6.

If your photographer has access to a digital camera, consider using an image reflection display at your reception.

Image Reflection Displays. Also consider creating an image reflection display—a stream of images displayed on a laptop or television—at the reception. It provides entertainment for the grandparents who may be tired and for any guests that do not like to dance. Properly placed, the display will not distract from the activities scheduled for your special day.

This display can be set up in three different ways, depending on your preference. First, consider keeping things simple: you can set up the laptop on a highboy cocktail table with a candle and a small flower arrangement. Place the display near the gift table or close to the exit. When people are leaving they will be astounded to see images from the day on these screens! You might also consider viewing your images on a large-screen

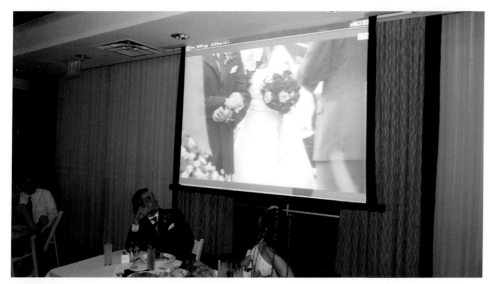

With the technology available today, you can consider showcasing your wedding images at the reception. Photo by Jeff Hawkins.

add a creative special touch to your event—it should not steal the show. For this reason, be sure that its placement doesn't dominate the mood of the room.

○ THANK-YOU GIFTS

If your photographer has used a digital camera to capture some of your images, discuss the possibility of having digital prints made at the reception and placed into special frames. You can also have miniature albums made for your bridal party attendants—either of these make great thank-you gifts at the conclusion of the reception. Of course, the presentation will take some preparation. Because you will present your gifts at the reception site, some preparations need to be made prior to the wedding day. You will need to select a frame and purchase thank-you cards to accompany each gift. Do not forget a gift bag!

TV. This choice is most commonly used when the television is already part of the décor, like at a country club. It is not recommended that you wheel the TV in on a cart, as it may ruin the ambience of the room. Finally, if you want to make a grand statement, hook up a laptop to plasma screens (flat, lightweight screens that can be hung on the wall like a photograph) and, during dinner, display the images made throughout the day. This display gives your guests something to look at and adds a little excitement to your special day. A word of caution: do not add music or special effects to your slide show. A slide show is designed to

With the latest photographic technology, qualified photographers with state-of-the-art equipment can print beautiful

20x24-inch prints with no pixelation or distortion. Framed 5x7- or 8x10-inch wedding images (commonly referred to as wedding day gift frames) are a very popular gift for parents, loved ones and even for the new husband from the bride! Most photography studios require a three-frame or three–gift album minimum purchase, because the help of an assistant is required and a special printer must be calibrated to suit the system. Make sure you coordinate the use of a private meeting room near the reception hall where the photographer or his assistant can turn on the lights and prepare your images.

Wedding day gift frames are a special touch. Photos and gift frames by Jeff Hawkins.

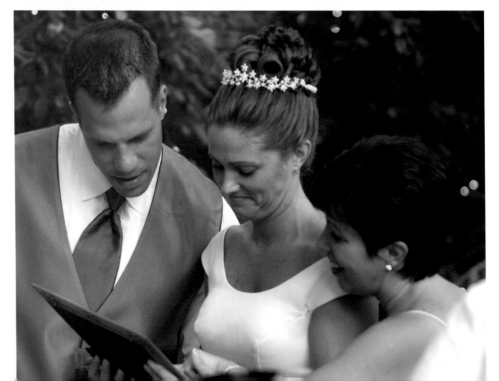

The tedious task of selecting a photographer is complete, but your pre–wedding day obligations are not. After analyzing your photographer's personality and style, firming up your budget and solidifying your paperwork, you'll need to discuss and schedule your pre–wedding day sessions.

Pre–wedding day meetings vary from studio to studio, but the most commonly scheduled appointments include the engagement session, formal bridal portrait session and a planning session.

O THE ENGAGEMENT SESSION

The first appointment scheduled is characteristically the engagement portrait session. This session should be scheduled as early as possible, preferably at least six to eight weeks prior to the wedding day. Depending on your photographer's style

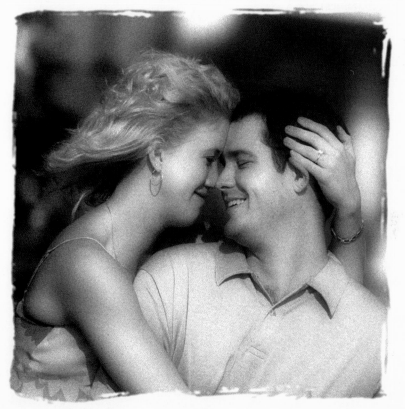

Discuss attire, location and props with your photographer prior to your engagement session. Photo by Jeff Hawkins.

Clothing Faux Pas

Clothing can make or break a portrait. Some clothing choices are better for portraits than others. For instance, you should never wear a short skirt or shorts, as these make posing more difficult. Long, flowing dresses, jeans, or khakis are better selections. Additionally, it's important to create a harmonious look in the portrait. When your clothing choice complements your fiancé's clothing, you look like you belong together. Also, this way, when a viewer looks at the portrait, he or she will be drawn to your faces, not your clothing!

of coverage, it can be a traditional engagement session using a backdrop or classic portrait lighting and posing techniques or can have more of a fashion or photojournalistic flair. Discuss wardrobe, location and props before your sitting. The engagement session is valuable, because it allows you and your fiancé to work closely with your photographer prior to your special day. It also gives the photographer the opportunity to determine your most photographic angles and features. Additionally, the photographer will get to know your tastes and preferences as he or she begins to see the images that you select. When attending an engagement session, consider the following suggestions.

Scheduling. Schedule your portrait session a minimum of six to eight weeks prior to your wedding day. The sooner it is scheduled, the better. If you will be scheduling an environmental session, keep in mind that the best time to photograph outdoors is usually early in the morning or late in the afternoon (the exact time will vary depending on the demographics, the heat index and the level of direct sunlight). Also remember that weekends are generally very busy for wedding photographers, so creative scheduling might be in order. Plan to take an afternoon off from work, or schedule the session before you go in to work one morning.

Clothing. Choose outfits that fit your personality and make you feel attractive. Make sure that the color and style of your clothing harmonizes with your fiancé's attire. Avoid heavy patterns or stripes; solid, neutral colors look best. Also, make sure that your clothing is suitable for the season in which you are being photographed—that one of you is not wearing shorts, and the other, a sweater.

Props. Start thinking about props—they can make your photograph unique. Consider a picnic basket, wine glasses, a musical instrument, or even a pet. Photographers can also often work with larger objects such as boats, sports cars, planes or motorcycles.

Location. Don't worry so much about the location! After you choose your wardrobe and props, schedule your appointment and discuss your thoughts

on a possible location. Don't become too set in any location preconceptions you may have, however. As a rule, photographers have access to many secret hideaways that you may not even know about.

Ideas. Become alert to interesting photographs. Look for romantic postcards or magazine advertisements. Often the photographer can recreate art with you as the subject!

Bring a Friend. Finally, consider bringing a close relative or friend along. He or she can stand next to the photographer and help you show a real smile— and sometimes the photographer can just as easily do two sittings at once! Perhaps you can give Mom the family portrait she has been talking about. (Remember to discuss this option with your photographer prior to scheduling your session.)

Fun. Have fun! Let the photographer capture you being you.

After your session, consult with your photographer about when your proofs

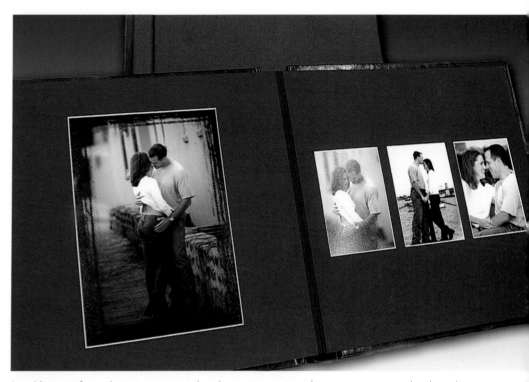

In addition to framed prints, many couples choose to create a designer engagement book to showcase their favorite images from the session. Photos and album by Jeff Hawkins.

will be ready and how they will be prepared. Proofs are the raw "sample" images from which you will choose your favorite image(s). Keep in mind that retouching and color correction may vastly improve the image. For additional

information on proofs and proofing methods, see chapter 6.

There are many ways in which your image can be displayed at your wedding reception. Be sure to discuss your options with your photographer. Many couples choose to display a love portrait. You might also consider a designer signature frame, a guest book, using an engagement photograph in the invitations or using these portraits as bridal party or parents' gifts. Wall folios are also very popular, as are custom-framed images. It is important to provide room in your pre–wedding day budget for any of these "extras" that you may be interested in. Generally, these products are not included in your pricing levels.

A signature-ready guest book showcasing your engagement portrait can be a fantastic addition to your reception. Be sure to use acid-free art pens and to assign someone to monitor the signing. You may also elect to add your names in calligraphy on each page. Photo by Jeff Hawkins.

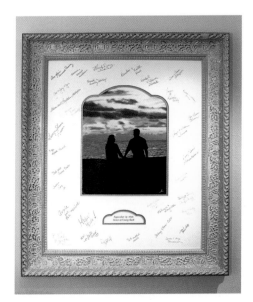

Using a signature frame—one specifically designed with a large mat that is ready to be autographed—is a unique way to record the names of everyone in attendance for your big day. Photo by Jeff Hawkins.

Custom framing your engagement, formal bridal and wedding day images adds an elegant appeal. Consider displaying your framed images at the reception entrance. The price of custom-framed images will vary based on the image and frame style selected. Photos by Jeff Hawkins.

The second appointment scheduled is the formal bridal portrait session, which is scheduled three to six weeks before the wedding. Be sure to tell the bridal shop when to have the dress ready! While you may be reluctant to schedule your session for fear of damaging your dress, remember that a formal bridal session is essentially a dress rehearsal for your big day. After the session, you may find out that the florist, makeup artist, hairstylist, or even the photographer have a vision that's different from yours. If you find that you're unhappy with your hair, makeup, flowers, etc., on the wedding day, it will most likely be too late to correct it. The formal portrait session provides you with the opportunity to make any necessary changes. The session also gives the bride a chance to become comfortable in her dress. Photographer Doug Box believes that when a bride puts on her dress and walks back and forth at a bridal shop, she is not really "wearing" her dress—she doesn't quite get the full effect, and doesn't know how it will feel to live in the dress for the day.

In a recent interview, Doug noted that a large number of his brides change something about their hair, makeup, or dress after a bridal portrait. He recalls a particular bride whose dress seemed the perfect length at the bridal shop, but at the portrait session suddenly seemed a bit too long.

Another benefit of the formal portrait session is that you will receive a wonderful portrait that captures the beauty of your special dress. Doug also points out that having a bridal portrait on display at the reception provides everyone with the opportunity to take a close look at the details that make the dress perfect while the bride is walking around laughing, talking, dancing and having a great time. Before scheduling your session, there are some things to consider.

Location. Discuss with the photographer where the session will take place.

A formal bridal portrait session is a wonderful way to prepare for your big day. Think of it as your dress rehearsal! Photo above by Jeff Hawkins. Facing page photo by Andy Marcus.

Again, for environmental sessions, the best time to photograph outside is usually early in the morning or late in the afternoon. (Again, the time will vary depending on the demographics, the heat index and the level of direct sunlight.) If the session will be conducted indoors, then, prior to the wedding day, you may need to get permission to photograph on location. (Don't try to get by without it—your photographer will most likely be dressed professionally, and wedding attire typically flags people's attention.) Also remember that weekends are generally very busy for wedding photographers, so creative scheduling might be necessary. Again, schedule your session before you go in to work, or try to get an afternoon off to attend the session.

Dress and Veil. Consult with the dress shop to coordinate the arrival of your dress and veil. Photographer Deborah Lynn Ferro believes it is important to use your train and your veil when creating a bridal portrait. She adds, "A

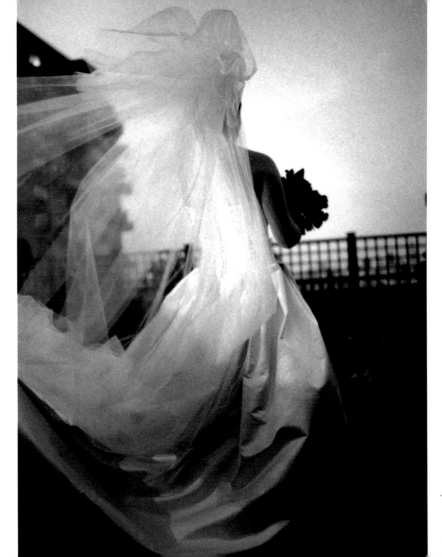

Long trains and beautiful veils will add beauty and elegance to your portrait. Photos by Andy Marcus.

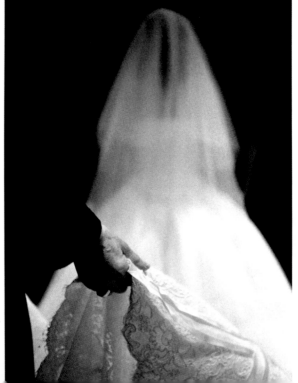

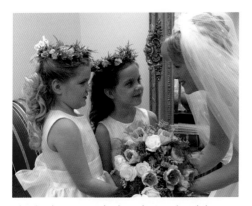

This bride even picked up the cool pink hues in her bouquet by adding a touch of pink lip gloss on her flower girls' lips. They all have a fresh, springtime glow! Photo by Deborah Lynn Ferro.

long veil can add creativity to portraits and a long train creates instant glamour in the portrait."

Flowers. Discuss the formal session with your florist and ask her to make up a complementary or smaller version of your bouquet. Photographer Deborah Lyn Ferro also recommends, "When choosing a bouquet for a formal bridal portrait, keep in mind that flowers should not overpower the face. You want

ABOVE—Select flower colors that will coordinate nicely with the bridal party and the church and venue décor. Photo by Douglas Allen Box. RIGHT—While bright gold roses are very beautiful, be sure to consider how the photographs might render the flowers versus the skin tone of each of the members of your bridal party. If several of your bridesmaids are fair-skinned, you might be better off selecting a complementary color. Photo by Stewart Powers.

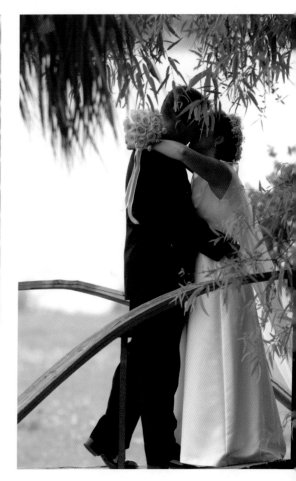

[viewers] to be drawn to the bride's face before the flowers."

Assistants. Recruit assistants to help you during your portrait session. You may be intimidated by a formal bridal portrait session for fear that you might damage your dress. This is understandable. Bring along your maid of honor or perhaps your mother. The more help, the better! Your assistant can help you get ready and ensure that your dress is kept off of the ground as much as possible. Bring a flat bedsheet (or two) to the session and have your assistant place it on the ground before your dress is set down. This will allow you to sit as needed, without worrying about damaging your dress.

Communication. Remember to pull the reins back as required. If you hired a passionate artist, you may get caught up in his/her creativity and excitement and your session may start moving fast. Understand that it is your session and your dress. If you need to communicate with your photographer, simply say, "I know you are excited and that's great, but I want to take it slow and be more careful today." The day of the wedding, the photographer can typically be as passionate as possible—after the ceremony, you won't be as concerned about getting your dress dirty.

Hair and Makeup. Schedule your hair and makeup appointment with the same person whose services you plan to use on the wedding day, and make sure

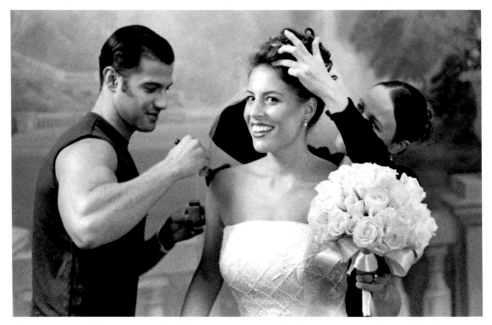

For your pre-wedding session, schedule an appointment with the same person who will be doing your hair and makeup on your wedding day. Photo by Andy Marcus.

Be sure to hire a professional makeup artist who has experience with wedding photography. Photos by Jeff Hawkins.

that your makeup is done exactly the way you will wear it later. Recently, a bride selected makeup in shades of pink and purple for her spring wedding. The colors looked beautiful with her dark hair and dark eyes, and she looked fabulous! However, when she did her formal bridal portrait session, she pulled out a bright vibrant red rose bouquet. In all her for-mal portraits, her lips jumped out of the photograph! She did not create harmony from head to toe! Makeup and flower colors are more obvious when you are only wearing white everywhere else!

In another instance a bride selected a beautiful pink flower bouquet to hold on her special day. She was more of a natu-ral-looking bride, so together with her makeup artist they selected shades of brown for her eyes, blush and lips. Everything looked beautiful, except for her lips! The brown shade of lipstick was not neutral, it had an orange undertone. Once on, it picked up a caramel color. Since she did not do a formal bridal por-trait, we did not discover the problem until the wedding day. This would not have been a dilemma if the bouquet and the bridesmaids' dresses were rust, tan or coral. But together with the bright pink colors, her lips looked huge! Her lips and bouquet were very noticeable.

Again, a formal bridal portrait session provides you with a pre–wedding day dress rehearsal. It allows you to see the final results pieced together and also provides you with the time to make any necessary changes!

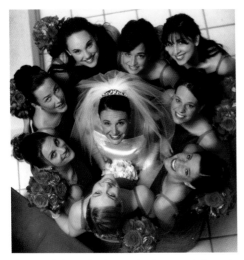

If one of these bridesmaids chose pink lipstick, it surely would be noticeable in the image! Photo by Ken Sklute.

Ten Common Makeup Mistakes

All eyes will be focused on you—make sure every inch looks picture-perfect!

1. Do Use Proper Skin Care. Start a basic skin care routine at least two to three months before your wedding day. A morning and evening regimen of cleansing, freshening and moisturizing primes your face for a beautiful makeup look. If you already use a skin care program, try altering a few of the products. Often skin becomes stagnant and comfortable if the same products are used for too long.

2. Do Wear Makeup. Frequently, the filter a photographer uses softens your look and washes you out. Also, most brides love black & white photography, but without the proper makeup your features become drab, especially since they are surrounded by a white dress and veil. Use makeup to add pizzazz to your portrait and define your best features. Minor imperfections can be color corrected using concealer. A talented makeup artist can give you the natural look you may desire while enhancing your features with makeup. Again, you will be able to alter your makeup based on the results of your pre-wedding portraits.

3. Do Create Color Harmony. Strive for color harmony between your makeup, clothing and surroundings. To harmonize, select flowers and dresses with a single undertone; for example, choose accessories within either the cool (blue undertone) or warm (orange undertone) color families. Harmonize your lip color, cheek color and nail color, too. The entire bridal party and important family members should all follow this rule. Neutral brown makeup colors photograph the best in both black & white and color portraiture. Your makeup should work well with the prominent colors in the ceremony and the reception site as well. If the church has a bright orange/red carpet, you probably should not select a purple bridesmaid's dress, purple flowers and purple eye shadow. If you do not heed this advice, the colors in your church and bridal party photographs will clash and your images will not be as beautiful as the samples you viewed in your photographer's studio.

4. Consider Neutral Colors. Consider color harmony when selecting your eye shadow, as well, but bear in mind that neutral color will bring out your eye color more than a more prominent shade. From a photographic point of view, neutral brown eye shadow looks best on brides with blue, green or hazel eyes, and cool-

er-toned color look best on brides with brown eyes. Brown shades with a purple, fig or blue hue are a popular choice; they make the eye color, not the eye shadow, the focal point.

5. Do Use Waterproof Mascara. This is one of the happiest moments of your life, and undoubtedly you'll shed a few tears. Make sure you, your bridal party and all the female members of your family use waterproof mascara. Also suggest layering black and brown mascara to create a longer-looking lash. If you have light lashes, first apply brown mascara, then apply black mascara to the tips of your lashes. Do the opposite if you have dark lashes.

6. Do Use Lipstick and Lip Liner. Select a lipstick rich in moisturizers for the ultimate kissable lips! First line then fill in your entire lip, then use a brush to apply color. Reapply for staying power. Add a touch of gloss for shine if you prefer, but avoid a frosted lip color. Frosted lipsticks are not always picture friendly!

7. Do Wear the Correct Foundation Shade. Select a shade that matches your skin at the jawline. Blend it well, especially in the hair- and jawline areas! This gives the skin a smooth finish.

8. Do Use Facial Powder. A translucent facial powder will set your makeup and provide a matte finish. It also helps prevent oil breakthrough and shine. Always select powder in the shade closest to your skin tone. Pressed powder is portable and can be used throughout the day.

9. Do Use the Correct Blush Brush. Blush should provide a soft glow. With a white veil and a white dress your wardrobe will create a highlight for your face. Adding a splash of color is important for creating contrast and a healthy glow. Blush should never look streaky or blotchy. For a sheer application use a blusher brush. Lightly dust facial powder over the blush to tone down the color. Wherever you lay the brush first is where the most color will be applied.

10. Do Use a Professional! Great skin care and makeup isn't something you buy, it is something you learn. Hire a professional to help you. Make sure she has ample experience in applying wedding-day makeup. Get a referral from your photographer; she will usually be able to tell you who will make you look the most beautiful on your wedding day and in all your photographs. Not every cosmetologist knows how to do hair and makeup for the camera. Also, be certain to discuss your color selections with your makeup artist.

The final stage of your pre–wedding day obligations is the planning session. You have most likely spent some time with your photographer between the interviews, the engagement and formal portrait sessions and the viewing of your proofs. Hopefully, you are beginning to develop a relationship and a bond with him or her.

The planning session will help you to finalize all the details of your day and make sure everything is coordinated efficiently and effectively. This session is generally scheduled for one or two weeks before your big day. At your planning session, you will need to narrow down the time lines, compile your must-have image lists and discuss any restrictions or requirements.

The first portion of the pre–wedding day session should be spent choreographing the wedding-day time line. This should be reviewed with the wedding coordinator, the people in charge at the

ceremony site and the reception facilitator. The couple should consider the style of coverage they selected and how much formal and candid portraiture they want to have captured. Meshing traditional and photojournalistic styles of coverage can sometimes be tricky for the photographer and the couple when working with a limited time span. Reviewing exactly what you want with the photographer beforehand is important. Discuss what is involved with taking images before the ceremony, after the ceremony and, sometimes, even after the reception. To formulate a plan, review the must-have photo list found on page 72, and update it so that it reflects all of your personal image needs. Be sure to consider any special religious or ethnic traditions that you want captured on film, as the photographer might not otherwise be prepared for these images. Next, select the time frame that works best for you.

Time Frames. There are three "time lines," you should consider when planning for your wedding images. You will need to select the one that best suits your particular needs.

PRIVATE TIME SCHEDULE. Many photographers schedule private time—a concept designed to promote time management—and conduct the formal posed images before the ceremony. Private time is typically conducted three hours before the ceremony and can be done with the bride and groom alone or with the entire bridal party. During this time away from the guests, the photographer can capture images of the couple, the family and the bridal party interacting naturally.

Private time goes against the grain of a long-standing tradition—that of the bride and groom not seeing each other prior to the wedding ceremony. This tradition arose from the fear that in an arranged marriage, the bride or groom could elect to rebel and cancel the arrangement if they had the chance. The private time concept throws out tradition and allows the couple to share a private

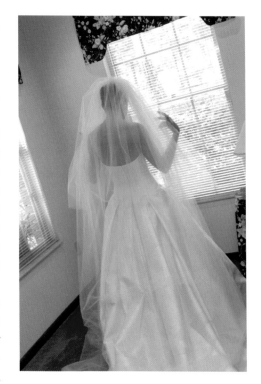

moment before the ceremony. At this time, the flowers are freshest and the hair and makeup look their best, making it the best time to capture photographs. Private time alleviates the stress and pres-

Private time can be very special for a couple. It provides an opportunity to reflect on the events to come, to pray together or just to enjoy some simple solitude. Photos by Stewart Powers.

sures of the day and changes the tone of the posed photographs.

When scheduling private time, discuss with your photographer how you and the groom will see each other for the first time to ensure the most memorable scenario. Often the bride will be staged in a room holding her flowers with her train flowing and looking breathtakingly beautiful and then the photographer will cap-

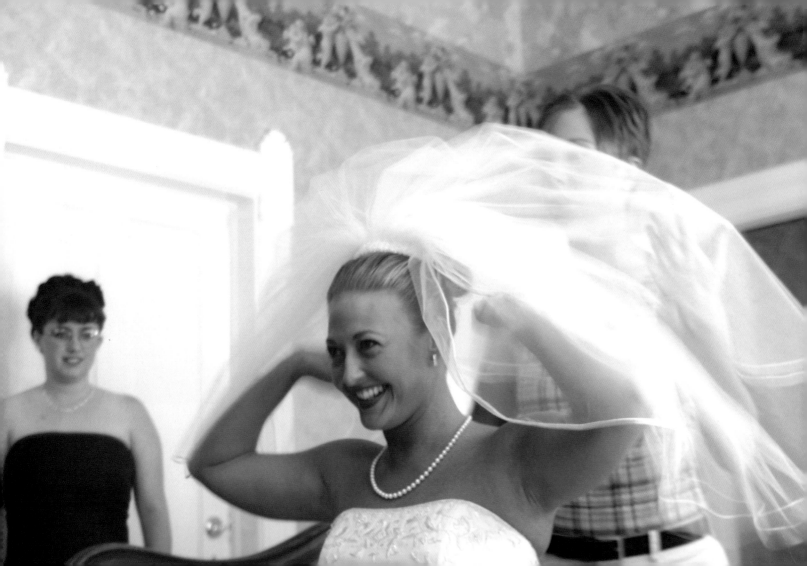

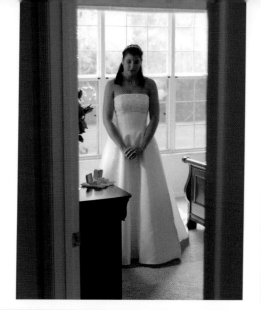

Private time makes possible the creation of some very special images. (However, make sure to allocate enough time to get freshened up or remove sand from your shoes before walking down the aisle!) Left and facing page photos by Stewart Powers. Photo directly below by Jeff Hawkins. Bottom photo by Susan Powers.

ture the pacing groom's entrance. If you opt for private time, after the initial meeting, ask the photographer to leave you alone to enjoy a private "moment." (This can last anywhere from five to forty-five minutes, but remember, it will affect the time line for your day.) This time alone allows you to pray together, discuss what you are about to do, enjoy each other's company, spend some time alone away from confusion and chaos, and simply reduce stress.

When you are ready to appear, you may get all of your formal portraits out of

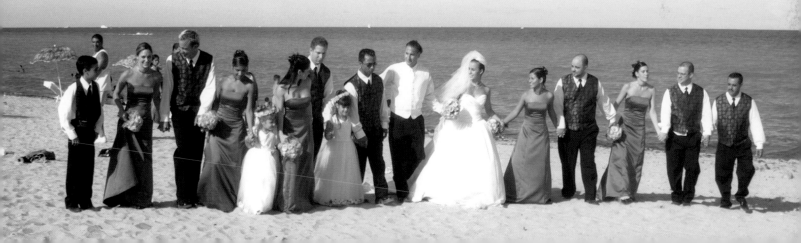

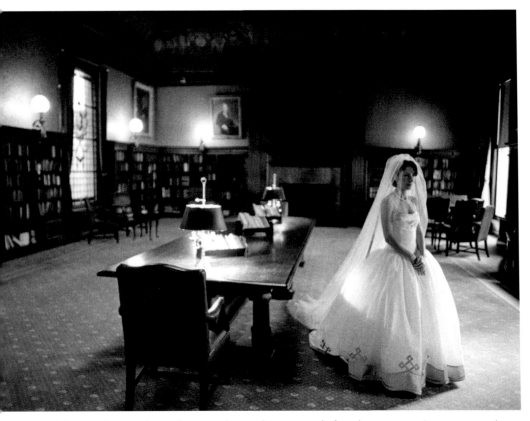
Ask your photographer to begin working an hour or two before the ceremony. Pre-ceremony photographs can be full of emotion! Photo by Andy Marcus.

the way before the ceremony begins. Overall, most couples that experience private time are pleased with their decision. Using private time allows the photographer to give the client complete coverage and produce fabulous images, which is very advantageous for all parties.

To schedule private time, you'll need to map out the major events that you will need to devote your time to throughout the day. To clarify the sort of planning and timing that's required for private time, we'll look at a schedule used by Terri and Thomas.

Terri and Thomas are getting married at the Holy Church at 3:00 p.m. on Saturday and have opted for a private time schedule. Below is a sample of the time line that they have worked out with their photographer.

Pre-Ceremony
• Flowers will arrive at 1:00. (Do not schedule your portrait sessions without flowers! You will not want bridal party images without

bouquets, and it is unnecessary to take the time to photograph these sessions twice.)

• Bride will be dressed and ready by 1:30.

• Groom will enter the private time room at 1:30.

• The couple will begin their private time session at 1:30 at the Holy Church.

• The bridal party and family will meet at the front steps of the Holy Church at 1:45.

• The pre-ceremony session will conclude at 2:30 to allow the couple time to freshen up. (Bride must be "tucked away" at least ½ hour prior to the ceremony).

Ceremony

• Post-ceremony photographs will begin at 3:30.

• Post-ceremony portraits with grandparents and other relatives (as needed) will begin at the conclusion of the ceremony (minimal time required).

TRADITIONAL SCHEDULE. This option is perfect if the couple wants the groom to first see the bride-to-be as she enters the church and walks down the aisle. Various portraits can be made of some of the players in the wedding early on (pre-ceremony), but if you want to uphold the tradition of staying out of the groom's sight before the ceremony begins, then your couple's portraits will not begin until the ceremony does. Of course, careful coordination and time management will come into play. To ensure that the photographer has enough time to get plenty of images of you and the groom after the ceremony, he or she can capture the getting-ready images, images of the bride and her family, the groom and his family, guests arriving, the groomsmen pacing, etc., an hour or two before the ceremony starts.

To most couples, the details of the ceremony are a blur. Try to mentally prepare yourself for this moment in order to absorb as much of it as possible. Wearing your dress, practice walking down the aisle with your father so that when the real moment arrives you are not stuck

A wedding consists of many wonderful moments that pass in a blur—photos like this help preserve every detail. Photo by Kathleen Hawkins.

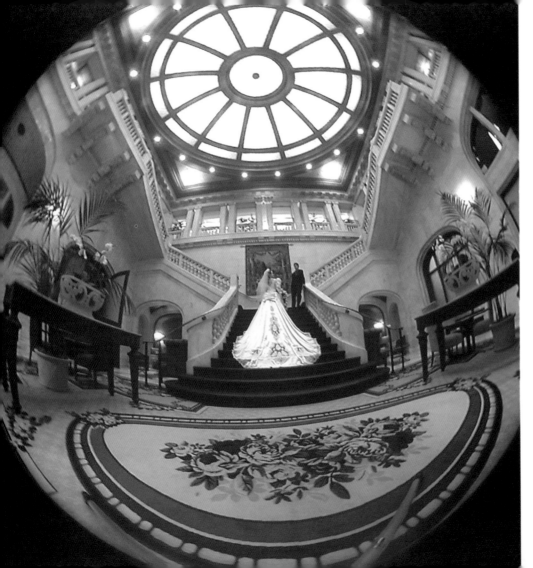

thinking about tripping or him stepping on your gown. Instead of looking down hopefully, you will be able to look forward and find your fiancé.

The groom can prepare himself as well. Typically, he cannot express his emotions, because all he can think about is that hundreds of people are waiting to see his response as he first lays eyes on you. Discuss with him the importance of being himself and tell him not to worry so much about showing his emotions. Most importantly, try to live in the moment and allow the photographer to capture your true emotions and feelings.

An example of the timing required for a traditional time line follows:

Ashlyn and Joe are getting married on Saturday at 12:00 p.m. at City View Park. Because they believe the bride and

When capturing the formal portraits after the ceremony, the photographer is required to work so fast that using special lenses and capturing different angles may not be an option. Photo by Patrick Rice.

groom should not see each other prior to the wedding, they have elected to have all of the bride-and-groom posed photographs taken after the ceremony. To make sure that their schedule flows smoothly, they plan to begin their session an hour or two prior to the ceremony. Their traditional time line schedule is shown below:

(*Note:* Times may be adjusted according to location, schedule and type of event.)

Pre-Ceremony
- Flowers will arrive at 10:30.
- Bride will be dressed and ready by 10:00.
- Bride's family and bridal party will be ready to be photographed at 10:30.
- Groom will arrive at ceremony site at 11:00.
- The groom and family will meet at the western side of the park for photographs at 11:00.
- All the posed images, excluding ones that include both the bride and groom, will be taken prior to the start of the ceremony.

(Bride must be tucked away at least ½ hour prior to the ceremony to stay out of the view of the guests and groom.)

Ceremony
Photo session begins immediately following the ceremony. (Allow a minimum of forty-five minutes after the ceremony for posed groupings. This can be adjusted based on the size of the bridal party and number of family members. When conducting post-ceremony portraits avoid receiving lines when possible, as this will reduce the amount of time available for portraits. If photo time is short at the ceremony site, consider conducting the portrait session at the reception venue.)

Reception
Additional images of the couple or bridal party will be taken at the reception location as deemed appropriate. (Clarify start and end time and locations.)

You have hired an expert and should not have to tell your photographer what type of ceremony coverage you are looking for. However, any unique desires or requests should be discussed. Photo by Susan Powers.

They Lived Happily Ever After

ABOVE—If you plan to conduct your formal sessions after your reception, be sure to allow sufficient time to freshen up and still take advantage of daylight. Photo by Jeff Hawkins. **RIGHT**—Discuss with your photographer prior to your big day any unique images you wish to have captured. Photo by Andy Marcus.

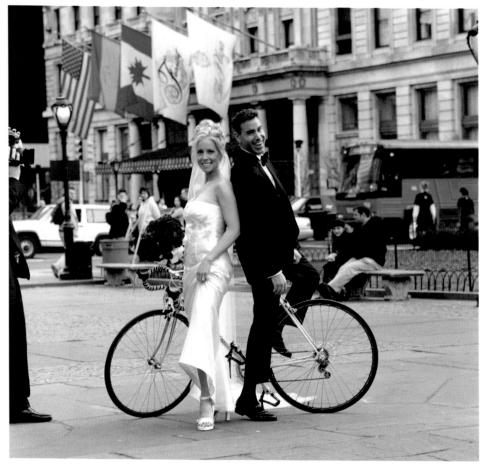

These images introduce the groom and his men before the ceremony. Photos by Ken Sklute.

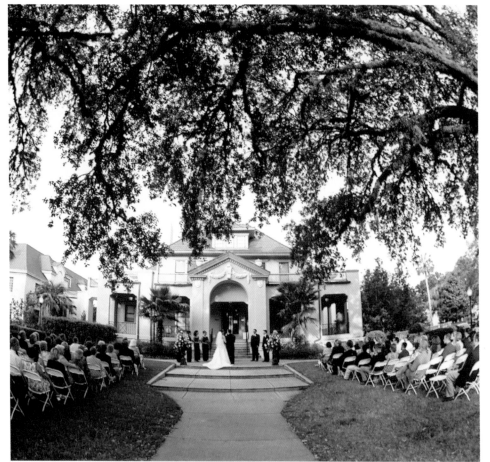

These are classic images of the ceremony that you should not have to go over in detail—be sure to notify your photographer, however, if your ceremony contains any special features you want to be sure to have captured. Left photo by Stewart Powers. Above photos by Ken Sklute.

Reception photos can be classic or contemporary but should be consistent in style with the rest of the wedding. Be sure to advise your photographer of any special attendees or unique events you want captured. Left photo by Deborah Lynn Ferro. Right photo by Andy Marcus.

 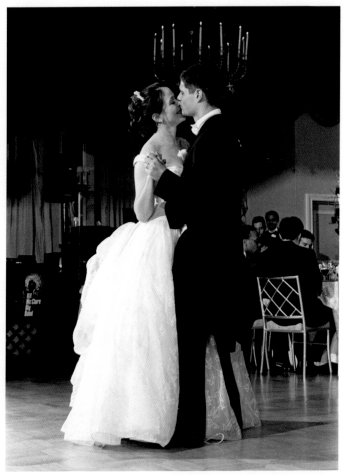

Careful time management should allow for a stress-free blend of traditional and photojournalistic portraiture for the bride, groom and the entire wedding party. Above photo by Deborah Lynn Ferro. Right photo by Ken Sklute. Facing page photo by Andy Marcus.

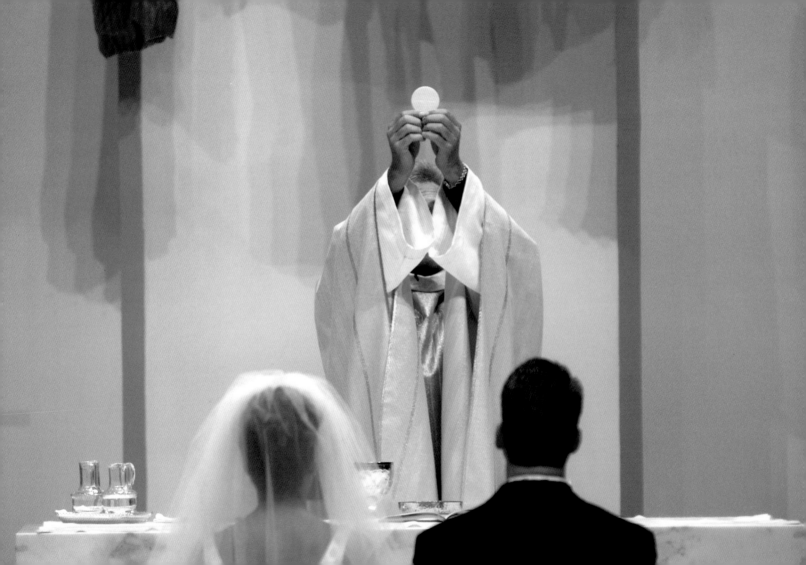

POST-RECEPTION PHOTOGRAPHS. For the couple that simply doesn't have enough time scheduled in their day or has an early morning ceremony, scheduling portraits at the conclusion of the reception may be an option. If electing this option, be sure to allow time for you and the bridal party to freshen up before the portrait session. Normally, the flowers, hair and makeup are not the freshest at this point. You will also want to make sure that your photographer is contracted to stay for a sufficient length of time after the reception to get all of the images you desire. Leave room in your schedule for the unplanned. One never knows what may happen and cause delays.

Post-reception photography is not the most popular approach, but it may be needed for your day. Many couples who have selected this option have been very happy with their decision.

For instance, Debbie and Mel, who are getting married at the Hawkins estate on Saturday, at 10:00 a.m., have opted to conduct all of their posed family photographs after the reception. A copy of their schedule appears below.

(*Note:* Times may be adjusted according to location, schedule, and type of event.)

Pre-Ceremony
- Flowers will arrive at 8:30.
- Bride will be dressed and ready by 8:30.
- Pre-ceremony photos will begin at 8:30.
- Bride's family and bridal party will be ready at 9:00.
- Groom will arrive at the ceremony site at 9:00.

Ceremony
- The ceremony will begin at 10:00.
- The reception will begin after the ceremony and be followed by formal portraits

Reception
- Additional photojournalistic images with the couple or bridal party at the reception location and throughout the event.
- Reception concludes at 2:00.
- Bridal party freshens up from 2:00 to 2:30.
- Post-reception portraits begin at 2:30 at the Hawkins estate. (Allow a minimum of forty-five minutes for posed groupings. This can be adjusted based on the size of the bridal party, number of family members and style of photography selected. When conducting post-reception photographs it is imperative that your bridal party doesn't wander off, leave early or arrive late for the session.)

Whether you select private time, a traditional session or post-reception photographs, allow time to get away from the hustle and bustle of the day and savor the moment alone. If you allow your photographer to discreetly tag along, it will allow him or her to capture some intimate, expressive moments. Careful time management should allow for a stress-

Photographic needs based on specific religions and cultural traditions vary. Make sure your photographer is familiar with yours. Photo by Jeff Hawkins.

The Must-Have Photo List

PRE-CEREMONY
- Bride and bridesmaids getting ready
- Bride by herself if formals were not done prior to the wedding day
- Bride with each parent individually (list stepparents if applicable)
- Bride with parents together
- Bride with each bridesmaid
- Bride with bridal party group
- Groom and groomsmen getting ready
- Groom by himself
- Groom with each parent individually (list stepparents if applicable)
- Groom with parents together
- Groom with each groomsman
- Groom with his groomsmen

CEREMONY IMAGES
- Bride in foyer with father, pending entrance
- Bride entering with father

- Parents lighting the unity candle
- Exchange of roses with parents
- Readers reciting verses
- Communion
- Ring exchange
- Gift exchange with step children
- Music solo by friend or musician
- Front image of parents sitting in pew (if allowed at ceremony location)
- Overview Balcony image (if permitted at ceremony location)
- Exit of bride and groom leaving ceremony, plus any other requested exit shots.

STANDARD POST-CEREMONY FORMALS
- Bride and groom together
- Bride and groom with bride's parents
- Bride and groom with siblings
- Extended family portraits (indicate whether or not both bride and groom should be in those images)
- Bride and groom with grandparents (These are easier to set up if you start with a larger family portrait and then break down into smaller groupings by removing extended relatives.)
- Bride and groom with groomsmen
- Bride and groom with bridal party
- Bride and groom with entire wedding party
- Special requests

RECEPTION IMAGES
- Entrances
- Special dances (list who and estimated time—i.e., first dance, mother and father dances, etc.)
- Fraternity or sorority songs or traditional activities
- Planned speeches or toasts
- Anniversary dances or grandparent dances
- Cake cutting
- Groom's cake cutting if applicable
- Garter toss or bouquet toss
- Gift presentations
- Planned exits

free blend of traditional and photojournalistic portraiture for the bride, groom and the entire bridal party.

Photo Lists. The must-have photo list is essential to proper planning, and goes hand-in-hand with the formulation of time lines. After all, the types of images you desire will dictate the time line to some degree.

Some photographers welcome photo lists, while others prefer that you don't prepare one. The main reason bridal consultants and bridal publications promote the use of these lists is to ensure that all of the photographs that are important to the couple are captured. An inexperienced or unorganized photographer might miss an important image without a list. An experienced professional photographer, on the other hand, will most likely use a system or routine to ensure that all groupings are documented. Providing these prepared photographers with a list will often muddle their routines and create havoc.

Photo lists can be a helpful resource, but they should not be so rigid that they stifle the photographer's creativity or cause him/her to miss the opportunity to capture spontaneous, emotional moments. Photo by Susan Powers.

Make sure to educate the photographer on any rules of etiquette for working with the priest, the officiate, the monk or the rabbi.

All of the traditional photographs and special-request images must be captured without hindering the photographer's creativity. If a photographer is forced to work solely from an image list he or she will be less likely to pay attention to emotions and activities around them during the formal portrait session. The standard images are not as commonly missed as the unusual ones or special requests. For example, an image of the bride and her stepfather alone is imperative to some, while to others it is unnecessary. These are the details that should be discussed prior to the wedding day.

You might consider selecting a friend or family member who isn't in the bridal party to coordinate your photographs. This person should be someone who has attended the rehearsal dinner and is familiar with both families. Discuss with this person all of the must-have images. Have him or her create a list and introduce them to the photographer or the photographer's assistant prior to the ceremony. Make sure the coordinator is careful not to step on the photographer's toes—he or she should be there to help make things flow smoothly, not to bruise the photographer's ego! Have the coordinator sit a few pews back and observe the groupings that are captured. If they notice an image was missed, they can bring it to the photographer's attention. They can also help round up any wandering guests needed for the shots. This way, the photographer can focus on lighting and posing, the bride and groom can focus on looking beautiful and no one has to solely rely on memory alone!

Here is a sample list of what your must-have shots should include. You will need to tweak and personalize this list to suit your family and your personality. Make sure to list the name and proper title of each person, as this will make the images easier to set up.

Discuss with your photographer any planned reception activities, including any nontraditional events that will transpire. Give him or her an itinerary of approximate activity times. For instance, indicate any important dances, the time that the bouquet toss and garter toss will occur and when you plan to exit. This way, the story line will flow and all important activities will be documented.

Finally, make sure that the venue does not have any restrictions against flash photography or photography in particular areas. You should discuss any ground rules with the management of the reception venue you have selected. Often there

are additional fees or rules for photographing on the property grounds. It is better to be in-the-know than in the dark.

The Final Step. In conclusion, before you wrap up your pre-wedding planning session, both the bridal couple and the photographer should be able to answer all of the following questions:

1. Where will you be getting ready, and at what time will you be ready?

2. When will you be conducting your posed portraits (private time, traditional session or post-reception)?

3. Does the photographer have directions to all locations?

4. Where will the flowers be delivered, and what time will they be delivered? Confirm they will be delivered before the first portrait is taken.

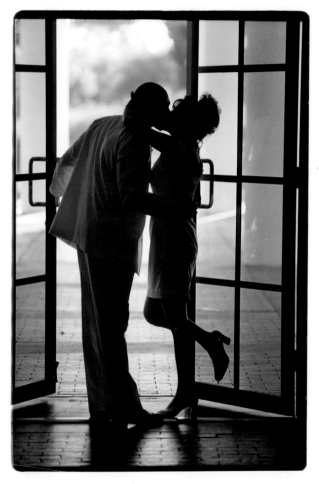

The photographer needs to be fully aware of your wedding-day schedule—from start to finish. Photo by Ken Sklute.

5. What time will the groom and his groomsmen be arriving at the ceremony location? Confirm they will have their boutonnières before portraits are taken.

6. Does the photographer have an in-case-of-emergency contact person and an emergency contact number?

7. Have you discussed in detail any planned exits, both from the wedding and the reception?

8. If the event is more than five hours long, will food be provided for the photographer and his assistant? If food will not be provided, what time would you prefer they break to eat?

9. Have you discussed any unique or special reception activities you would like to have photographed?

10. Have you provided your photographer with the names of the other service

Providing your photographer with a list of attending vendors prior to the ceremony will help make your day flow smoothly. A good, professional working relationship will eliminate any unnecessary stress on the day of your wedding. Photo by Ken Sklute.

providers you've contracted? Most photographers take pride in working closely with their fellow wedding vendors. Providing them with a list of names prior to the big day will allow them to coordinate any special details as needed.

Vendor List

	SERVICE PROVIDER	CONTACT PERSON	PHONE NUMBER
Church			
Officiant			
Reception venue			
Caterer			
Cake			
DJ/entertainment			
Videographer			
Florist			
Limo			
Tux			
Wedding dress			
Wedding consultant			
Hair/makeup artist			

5. The Wedding Day

The big day is almost here and you have coordinated as much as possible with your photographer. Now it is time to make sure you have created a picture-perfect event! Though you most likely have made all the photography related decisions you can make, there are still a few other factors you can consider to spice up your wedding day images. There may still be a few appearance issues and event considerations that need to be tweaked!

O READY YOURSELF FOR BEAUTIFUL IMAGES

The following guidelines will help ensure fabulous photographs. These basic suggestions will show you how to trim a few pounds and enhance your most flattering features.

Bouquet. The bouquet should be held at the belly button. Your elbows

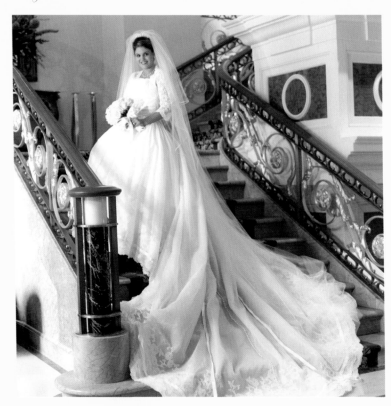

LEFT—The bouquet should be held at the belly button. Holding it too high will distract from the face. Photo by Andy Marcus.
FACING PAGE—Practice keeping your shoulders back and your chin out—not up or down. This will eliminate shadows under the chin and result in a more flattering image. Photo by Deborah Lynn Ferro.

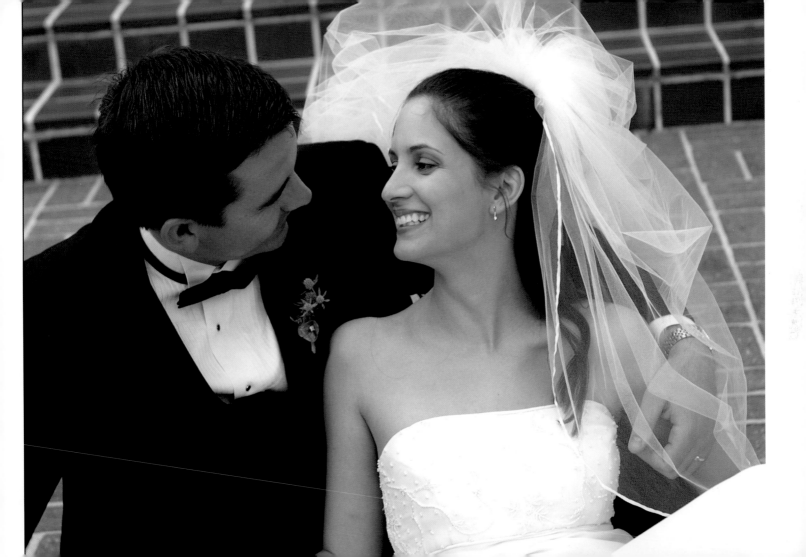

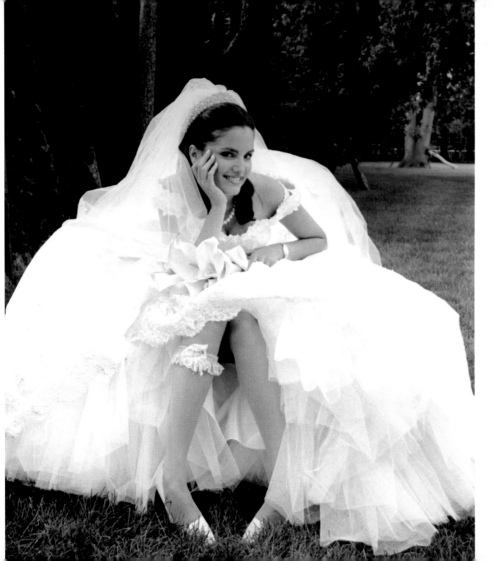

should rest on your hips. Often brides and bridesmaids will hold the bouquet too high, and by the time they reach the aisle it is over their face. (Many people believe that the bouquet was originally invented to cover a bulging belly!) Make sure to tilt the flowers forward. You may get the urge to tilt the stems forward and the flowers in, but that doesn't lead to the best photographs!

"The Turtle." Learn what is known by some as "the turtle." Pull your shoulders straight back and stick your chin out. Remember, it is the turtle you are going for, not the giraffe, so keep your chin out, not up! This will eliminate shadows and the appearance of a double chin.

Shift Your Weight. Learn to shift your weight away from the camera and slightly bend your front leg. In this position, everyone looks a little thinner.

Once you learn what angles flatter you the most, you will know how to assume your position and be ready every time you see the camera!

Catch Phrase. Create a catch phrase with your friends and bridal party members that you know will make you laugh. You can even use a secret saying from your bachelorette party! This will make your formal portraits look a little more natural. It will help eliminate stiff, uncomfortable poses and add a look of genuine happiness.

Posing During the Ceremony. Posing not only matters during your portraits—many couples need to strike a pose during the ceremony as well. Traditionally, couples make it to the end of the aisle and turn their backs to their guests. At the ceremony site, photographers sometimes capture only the backs of the bride's and groom's heads. Unfortunately, switching to a different lens doesn't help in this situation. Needless to say, these don't make for the

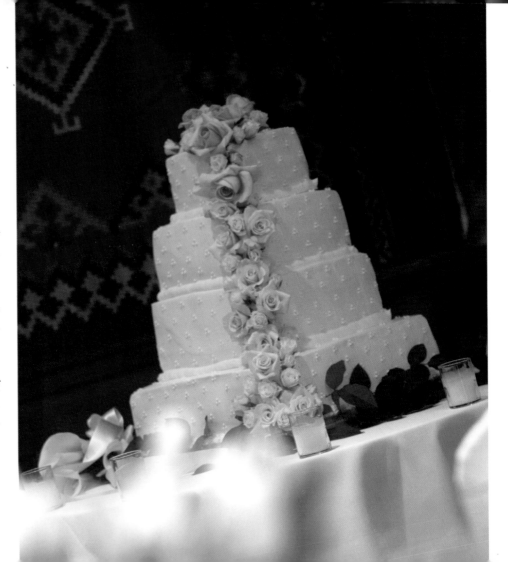

If it takes two hours to bake a cake and you remove it from the oven an hour early, it won't quite be the same—and you certainly won't enjoy it as much. Photography is much the same. It takes time to create the best possible results. When you aren't rushed, you'll also be able to relax and enjoy yourself much more. Right photo by Ken Sklute. Facing page photo by Deborah Lynn Ferro.

most emotional storytelling images. Practice turning your head slightly, so you are looking at each other instead of the priest, officiate, rabbi, etc. Show your guests your profile so they can see some of your emotions and reactions. It will make the "I dos" more enjoyable for your loved ones and make a better album!

Have Fun. Have fun, and be yourself. If you like to laugh a lot, then laugh. If you like to get sassy, then add some attitude. Just remember, it is your big day—enjoy it!

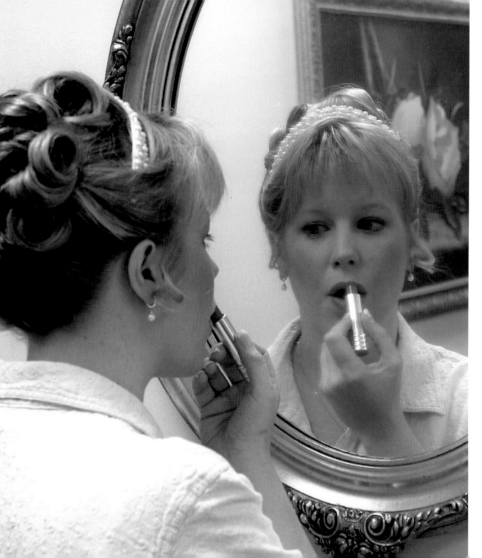

Have a friend carry your makeup and remind you when to touch up. Typically, touchups are required following the ceremony, after eating and after the cake cutting! Photo by Deborah Lynn Ferro.

Our panel of expert photographers were surveyed and asked to provide a list of the top tips for outstanding images. Their suggestions are found below. Now that most of the planning is done, you'll need to strike a balance between responsibility and pure enjoyment!

Don't Be Late! A wedding photographer's best friend—and worst enemy—is time. Allow enough time to create the best memories. Like a cake that takes two hours to bake, if you remove it from the oven an hour early, it won't be the same cake. Allow approximately 50 percent more time than you might expect for almost everything you need to accomplish on your wedding day!

Be Flexible. No matter how much planning you do, something small will most likely go wrong. Don't worry—most of your guests will never even notice! Have a good attitude about being flexible.

Enjoy Your Day! Even the best photographs in the world are not worth it if the couple does not enjoy themselves! Don't hesitate to tell your photographer what you like and what you don't.

Do Regular Touch-Ups. Have a friend or a bridesmaid carry your touch-up makeup and notify you when you need to reapply powder or freshen up. Be sure to get touch-up lipstick from your makeup artist. Though most photographers can retouch images, keep in mind that a shiny T-zone (the area across the forehead and down to the chin) can ruin a great image. Likewise, the bride who is photographed wearing white can appear washed out in the face is the makeup is not fresh enough.

Relax. Relax and allow the professionals you hired to do their jobs. If you have confidence in the photographer's ability you will be at ease—and it will show.

Relax and enjoy yourself—and have confidence in the professional photographer you carefully hired to do the job! Photo by Andy Marcus.

The big day has passed and your images are priceless! Most of your day may be a blur—but you don't need to worry, because you have made it a picture-perfect event. Every aspect of your appearance (and the appearance of everyone in your wedding party, too) was well thought out. You remembered the important posing techniques and coordinated your activities and events with the hired professionals. You hired a qualified photographer and can be confident that your wedding day was captured with class. Now, what is the next step? Viewing your proofs (image previews or "samples" from which you order the images you have your heart set on) and

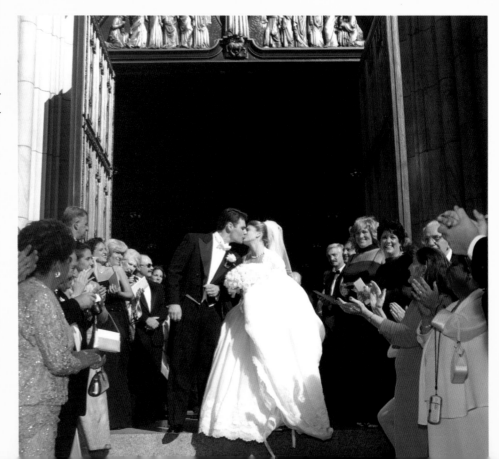

The day may have been a blur—but don't worry! Because of your attention to detail, you made it a picture-perfect event. Photo by Andy Marcus.

designing your album are generally the final steps on your wedding day journey.

There are many different types of proofing options available today. With the changes in technology, traditional paper proofs are not as common as they used to be. Instead, many studios are leaning toward video proofing, CD proofing and online proofing. These alternative types of proofing tend to be more convenient for the bridal couple. The new proofing techniques make life simpler—you won't have to lug heavy proof books around or collect orders from friends and relatives. Regardless of the type of proofing your studio uses, make certain that you understand any policies that may apply!

○ PAPER PROOFS

For decades, couples previewed their images in this way, and while many photographers use this method, it's losing popularity. Because a photojournalistic photographer photographs anywhere

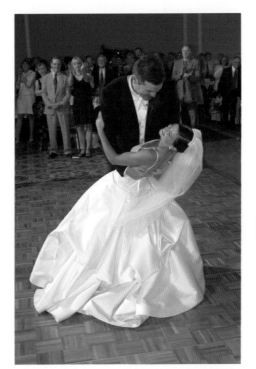

Due in part to the sheer number of photographs often created at weddings today, paper proofs are losing popularity. Left photo by Stewart Powers. Right photo by Susan Powers.

from 500 to 1000 images at an event, the complete proof book is a bit difficult to lug around. Due to the amount of time it takes to develop the negatives, edit the images, number the proofs and place them in the proof books, proofs are gen-

erally not available until three to eight weeks after the function. The length of time will vary based on the studio's production levels.

Once the couple receives their proofs, they are responsible for showing them to any interested family members and friends, and must collect their orders. The downside of paper proofs seems to outweigh the "benefit" of owning the uncropped, not-yet-color-corrected preview images, making paper proofs an unpopular choice for most brides.

○ CD PROOFING

Currently CD proofing is the most sought-after proofing style for most couples. The convenience that comes from being able to view the images rapidly and e-mail them to friends has created quite a stir. There are two types of CD proofing

CD proofing makes it easier for you, your family and your friends to preview your images—and for all of you to conveniently place orders for your favorites. Photo by Ken Sklute.

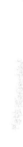

Most photographers who prepare copyright-released CDs include only the original wedding day images. These are not cropped, sized, color-corrected or retouched. They also do not include any of the image enhancements that a creative photographer can add to make the most of your images. Photos by Deborah Lynn Ferro.

methods, and it is important that you understand how they differ prior to making a purchase. The first type is the CD with low-resolution, non-copyable, non-printable .jpg files. These files can be created from film scans or from digital images. This allows the couple to view their images without lugging or mailing those heavy, bulky proof books—and without the responsibility of collecting orders. These images are numbered for ordering purposes and, depending on the studio, you may be able to e-mail them to family and friends (generally these images are copyright-protected and not printable).

The second type of CD proofing is a high-resolution digital file. As technology improves and copyright violations continue to rise, some photographers are waiving their rights to copyright protection and releasing large digital files to their clients. These files are not typically released until all album orders have been processed and are complete.

Please note that most photographers who prepare these copyright-released CDs are only releasing *original* wedding day images. Thus, these files still have to be cropped, sized and color corrected and any retouching or image modifications still need to be made. These CDs tend to serve mainly as a family heirloom unless you or someone you know is familiar with photo retouching software. Often couples that receive the second type of CD files store the CD in a safety deposit box for security, but elect to have images printed by the photographer for convenience and quality.

○ VIDEO PROOFS

Video proofing is not as popular as CD proofing because the image produced is a lower resolution image and is more difficult to view close-up—especially when trying to view a large family grouping. However, many studios still rely on the video proofing process for grandparents or family members who are not yet com-

If you use video proofing, consider asking for multiple copies of the tape to make it easier to share with friends and relatives. Photo by Jeff Hawkins.

puter savvy. On video proofing systems, the images are numbered for ordering purposes and rotated in a slide show viewing format. If the tape will be viewed by an older family member, request that your photographer make the image num-

bers as big as possible so he or she can easily order items of interest. Also consider asking your photographer for multiple copies of the proofing videos. The cost is probably minimal and it may make your lives much simpler.

○ ONLINE ORDERING

Finally, discuss the availability of online ordering with your photographer. This option simplifies the ordering process for everyone involved—there's no wait while the album circulates amongst your family members and circle of friends and there are no heavy albums to tote around.

You can create thank-you cards for each reception place setting with instructions for navigating the web site and any password required. Find an assistant to compile the e-mail addresses of anyone who may be interested in viewing the images online, and ask your photogra-

Online ordering simplifies the process for everyone involved and offers you some unique options.

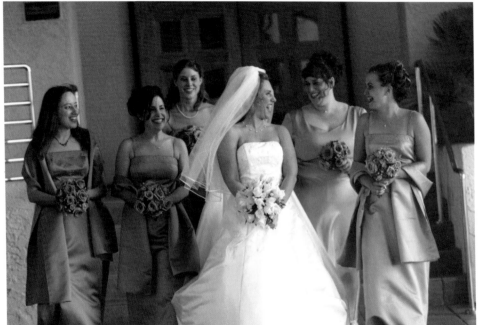

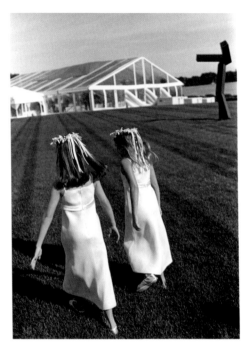

Online ordering gives everyone—from your bridesmaids to the parents of the flower girls— an easy, password-protected way to preview and order images. Left photo by Ken Sklute. Photos above and on facing page by Andy Marcus.

pher to notify him or her when the images are available. The assistant can then send an e-mail to your attendees to notify them that the images are ready for viewing.

Though many studios can process orders placed online, most couples and their family members simply use this service as a proofing tool. (Sometimes bridal party attendants order miscellaneous images online, but larger album orders are still being designed in-house.) If your photographer offers online ordering, make sure your images are password-

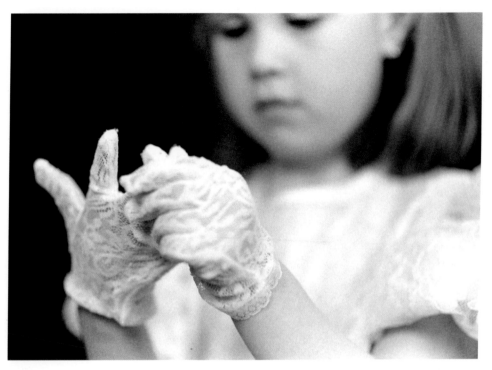

protected. Also, determine the ordering procedures, including the length of time your images will remain online.

With the new technology available for studios, proofs can often be available for viewing within days after the event. Once your proofs are available, schedule your album design session so that the studio can begin production as quickly as possible. (You may have scheduled the album design session during your pre-planning meeting prior to your wedding day.) Delays in the design can remove you from the studio's production schedule and prolong the time it takes to receive your final album. It's a good idea to get the job done after returning from your honeymoon, but before you have to go back to work.

7. Album Design

Scheduling a one-on-one consultation with the photographer or studio design team can be beneficial. Most studios care about the quality of the product they are delivering—they want to help their clients create cherished, personalized albums that really capture the magic of your special day.

○ THE DESIGN CONSULTATION

Scheduling an album design consultation with the studio will provide an opportunity for you to walk through the design process and discuss your album design with an expert, and will ensure that the end product will be a beautiful story-telling wedding album, not a scrapbook.

Once you have reviewed your proofs the album selection and design process can begin. Be open to the possibility of product changes or upgrades. In other

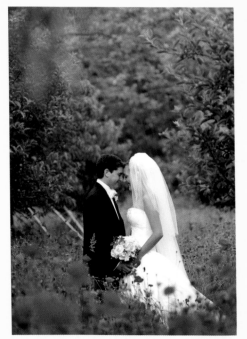 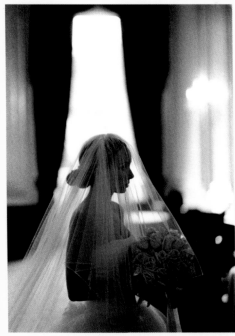

Many couples choose to create one album that showcases traditional images (left) and one story-telling album showcasing their favorite photojournalistic images (right). Photos by Andy Marcus.

words, if you selected a unique 100-image capacity designer album or coffee table book *prior* to your wedding, you may decide to upgrade to a more sizeable album/book once you've viewed 500 proofs. You may initially think you don't need many pictures, but chances are once you see the proofs, you will want more than you originally intended, especially if you hired a talented photographer.

Purchasing two separate albums—one album geared toward more traditional portraiture and the other with a behind-the-scenes storyline approach—is a popular choice for many couples. The album is a family heirloom that should be cherished by your family for generations, so selecting a high quality product with longevity is important.

Be open to modifications and you will end up with an heirloom you adore. There are many different styles of albums to choose from. Once you select the style that appeals to you the most, consider the endurance (i.e., is it timeless or trendy?) of the product and the durability of the design.

The Classic Album. The first style of album is called the classic album. This album comes in two different styles—(1) a traditional style album with page inserts and mats that "frame" the images or (2) a traditional album style with flush-mount inserts and no mats. In this type, the pages are the pictures. In either of these two album styles, you can customize the cover with a special image or a meaningful inscription. Covers traditionally come in an assortment of colors in top grain leather, distressed leather or a leather-like finish. The couple usually orders a classic album that will showcase 8x10- or 10x10-inch portraits. However, smaller classic albums are available as "parents' albums."

For classic albums, covers traditionally come in an assortment of colors in top grain leather, distressed leather or a leather-like finish. Photo by Jeff Hawkins.

The Digital Montage Album. The second style of album is the digital montage album. Photographer Andy Marcus mentions, "Brides who want a different, funky looking album tend to like the digital designer products, because of the ease of manipulation that can be done after the wedding to create unusual yet stunning effects."

There are two types of digital montage albums. In the first, images are printed on professional photographic paper; images in the other type are printed on specialty acid-free stock paper. The important element to consider here is the durability of the album and the archival quality of the product. If the album company guarantees the workmanship of the album, this type of product may be a unique coffee table display. The potential for rich imagery and text creates a unique

A great advantage of the digital montage album is the ability to get duplicate copies at a less expensive price. Photo and album by Jeff Hawkins.

expression of the couple's creativity. These albums will hold fewer images than classic albums, so they are generally purchased in conjunction with a more traditional type of product. A great advantage of the digital album is the ability to get duplicate copies at a less expensive price. This is typically a bonus for parents' albums or bridal party gifts.

The Image Box Display. The third style of album product is the image box display. The image box has a traditional album appearance on the outside but an artsy image on the inside. The box typically contains up to twenty-four square, heavy-duty mats, which can be removed and displayed on an easel or in a frame as desired. This is a less formal approach to showcasing your wedding day images and is usually used in conjunction with a classic or digital album or purchased for nontraditional parents.

If you are a budget-conscious bride, you may elect to order your own album rather than ordering through the pho-tographer. Be careful not to order cheap albums, as they may become damaged over time. Also discuss with the photographer print guarantee guidelines. Often if your images are not framed or placed in professional albums, you will forfeit the studio's guarantee. To protect your images, select albums that state that they are archival or use acid-free materials.

○ THE DESIGN PROCESS

After you select your product of choice, you will begin to design your album. There are usually two categories of design: the formal book and the story-telling album. You may combine the two categories in a single album or divide them into two separate ones.

To make the recreation of the wedding day story line easier for you, many studios use an album design software program. These programs make image layout easier and eliminate the need to lay proofs on a table to attempt to visualize the final outcome. When using an

When using an album design program, a drag and drop concept is used to create the image layout.

album design program, a drag and drop concept is used to create the image layout. In the end, you will be able to view what the final product will look like before it goes into production!

When selecting the album cover and page style you prefer, keep in mind that the same color harmony rules that applied on your wedding day will apply in the design process. If the church's interior featured a lot of ornate gold fix-

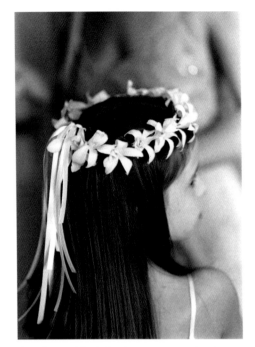

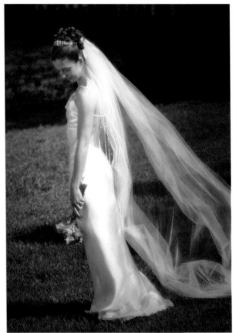

Avoid using black & white images and color images together. Even the strongest black & white photos can be overwhelmed by a nearby color frame. Left photo by Andy Marcus. Right photo by Jeff Hawkins.

tures, do not add silver edges around your pages. Dark brown and black pages and accents are very popular because they showcase the images without clashing with the colors of the church, the dresses, flowers, etc.

For the best visual flow in your album, never use black & white and color images on the same page. Showcasing the two styles on facing pages is acceptable, but should not be done excessively.

Additionally, when selecting image sizes remember that 3x5-, 4x5- and 5x7-inch prints will be used most to design the wedding story line. Reserve 8x8-, 8x10- and 10x10-inch prints for posed groupings or for momentous events like the cake shot or the first dance.

Furthermore, each action should have a reaction. This will eliminate a scrapbook approach and keep your story line in perspective. For instance, you might place an image of you dancing with your father next to one of your mom crying while she is watching.

Finally, a successfully designed album will lead the viewer through the events of the day by using "bookends." This means that each image should direct the viewer's eye toward the center of the book, not off of the page. For example, if your mom is pictured in profile, and is facing the left-hand side of the page, her

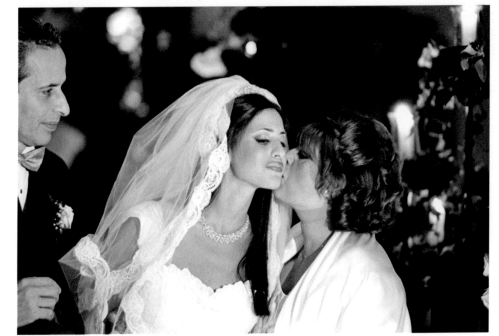
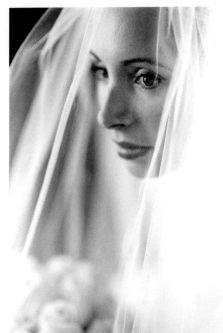

Each image should direct the viewer's eye toward the center of the book, not off of the page. Usually, this means placing the photos so that the subject is facing toward the center of the book. Accordingly, the photo on the left would be a good choice for a left-hand page because the bride's face (the center of interest) faces to the right edge of the frame. The photo on the right would be excellent on a right-hand page. Photos by Andy Marcus.

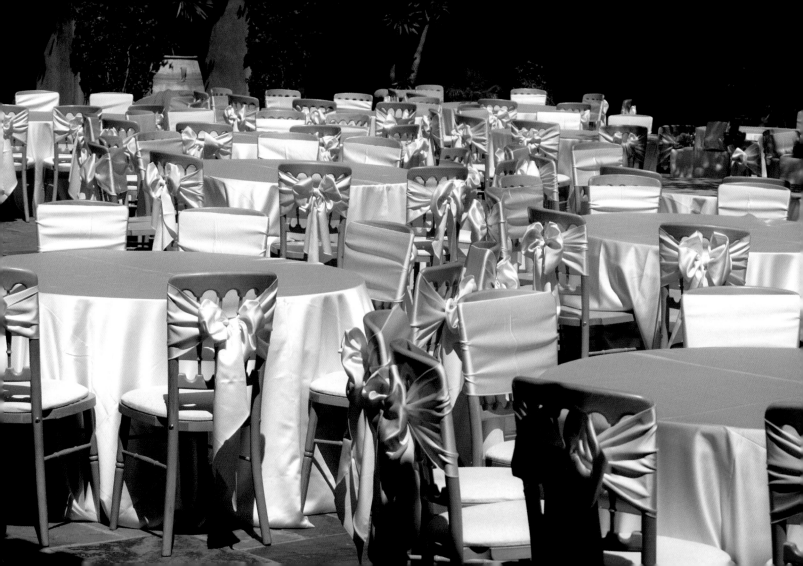

Setup shots help build continuity and take the album's viewers through each phase of the day. Photos by Ken Sklute.

image should be used as a left-hand page so that she faces the spine of the album.

Also be sure to arrange the images with continuity. Lead the viewer where you want them to go with setup shots (the cake, church, room setups, etc.). This will take your viewers into the next event. For example, to document your arrival at the reception, you would open the page with a room setup of the reception. This is the visual cue that something (in this case, the location) is about to change.

After you have selected your product and designed your album, the studio will begin processing your requested order. Album production time will vary for each studio based on the type of album and the quantity you've ordered; in general, you should receive your album in two to six months. Prepare to be patient. If your album is being custom-made for you, there are many time-consuming processes involved. You don't want shortcuts taken in the process. When your album is finally complete and ready for pickup, make sure to take the time to inspect it carefully before leaving the studio. After you return home, don't forget to add it to your homeowner's insurance policy. The album is a priceless investment; you want to be certain it is replaceable if it is ever damaged.

Closing Thoughts

In closing, remember that an image of a person or a family group is a symbol of a life that is always changing and will eventually end. One never knows how important the next photograph will become. Photographs help us recall and share precious memories of the times, events and people in our lives—even those that are long gone.

The tips offered in this book have given you the tools you need to select a great photographer—one who considers photography a privilege, not a job. The products you have chosen will help you and your family pass your memories from generation to generation.

Use the knowledge you have gained from this guide with pride. Always follow your heart and remember: Photography is never expensive, it is priceless!

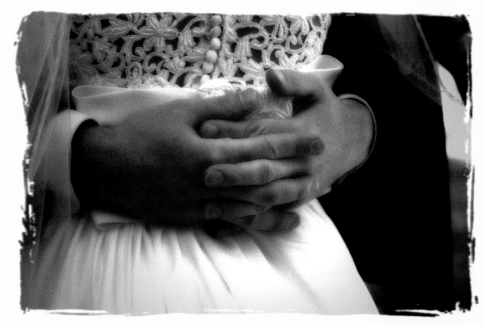

Hold on tight to your memories and cherish them forever. Life is precious, what is here today can be gone tomorrow. Photo by Kathleen Hawkins.

Photo by Ed Pierce

Kathleen Hawkins spent nearly a decade teaching marketing and business courses at a private university and is presently on the national speaking circuit for photographers. She proudly served on the board of directors as the president of the Wedding Professionals of Central Florida (WPCF) and as affiliate vice president for the National Association of Catering Executives (NACE). Together with her husband, Jeff, Kathleen is pleased to have authored *Professional Techniques for Digital Wedding Photography* and *Professional Marketing & Selling Techniques for Wedding Photographers,* both of which are published by Amherst Media. She is an active member of the Wedding Professionals of Central Florida (WPCF), the Professional Photographers Association (PPA), the Florida Professional Photographers (FPP) and the Wedding and Portrait Photographers International (WPPI) organization.

Thanks!

Special thanks go out to our panel of expert wedding photographers for their contributions and advice. Their knowledge of this industry and willingness to take time out of their busy schedules is greatly appreciated.

If you'd like to learn more about any of these gifted photographers or view more of their image, please visit them via their web sites.

Ken Sklute of
Contemporary Images
Tempe, Arizona
www.contemporaryimagesltd.com

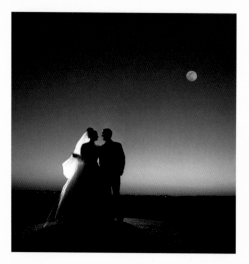

Douglas Allen Box of
Doug Box Photography
Caldwell, Texas
www.dougbox.com

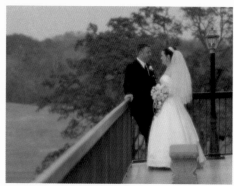

Andy Marcus of
**Fred Marcus Photography and
 Videography**
New York, New York
www.fredmarcus.com

Jeff Hawkins of
Jeff Hawkins Photography
Orlando, Florida
www.jeffhawkins.com

Stewart and Susan Powers of
Powers Photography
Gainesville, Florida
www.powersphotography.com

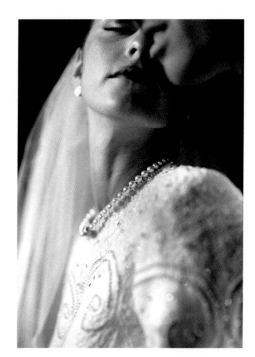

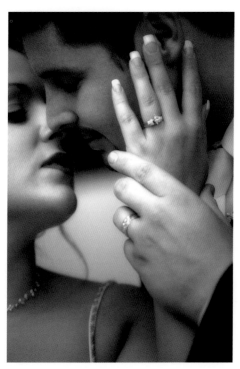

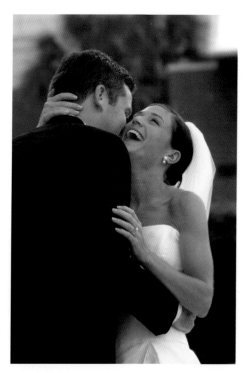

*Patrick Rice, Barbara Rice
and Travis Hill of*
Rice Photography
North Olmsted, Ohio
www.ricephoto.com

Deborah Lynn Ferro of
Signature Studio
Jacksonville, Florida
www.rickferro.com

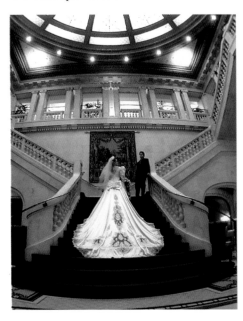

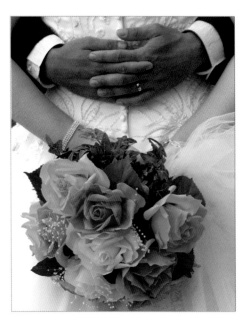

Other Books from
Amherst Media

Professional Secrets of Wedding Photography
2nd Edition
Douglas Allen Box

In this book, over fifty of Douglas Box's acclaimed portraits are individually analyzed to teach you the art of professional wedding portraiture. From natural light portraits to simple single and double light images, you'll learn the techniques needed to create top-quality results. Lighting diagrams, posing information and technical specs are included for every image. $29.95 list, 8½x11, 128p, 60 full-color photos, order no. 1658.

Infrared Wedding Photography
Patrick Rice, Barbara Rice & Travis Hill

Three award-winning photographers present step-by-step techniques for adding the dreamy look of black & white infrared to your wedding portraiture. Capture the fantasy of the wedding with unique ethereal portraits your clients will love! $29.95 list, 8½x11, 128p, 60 images, order no. 1681.

The Art of Bridal Portrait Photography
Marty Seefer

Learn how you can give every client your best and create timeless images that are sure to become family heirlooms. Seefer takes readers through every step of the bridal shoot, ensuring flawless results. From increasing your creativity, to customizing a flattering look for each client, this book covers all you ned to know. $29.95 list, 8½x11, 128p, 70 full-color photos, order no. 1730.

The Best of Wedding Photography
Bill Hurter

Learn from the editor of *Rangefinder* magazine how the top photographers in the wedding industry transform special moments into lasting romantic treasures. Features posing, lighting, album design and customer service, as well as images from over twenty award-winning wedding photographers. $29.95 list, 8½x11, 128p, 150 full-color photos, order no. 1747.

More Photo Books Are Available

Contact us for a FREE catalog:
AMHERST MEDIA
PO BOX 586
AMHERST, NY 14226 USA

www.AmherstMedia.com

Ordering & Sales Information:

INDIVIDUALS: If possible, purchase books from an Amherst Media retailer. Write to us for the dealer nearest you. To order direct, send a check or money order with a note listing the books you want and your shipping address; Visa and MasterCard are also accepted. For domestic and international shipping rates, please visit our web site or contact us at the numbers listed below. New York state residents add 8% sales tax.

DEALERS, DISTRIBUTORS & COLLEGES: Write, call or fax to place orders. For price information, contact Amherst Media or an Amherst Media sales representative. Net 30 days.

1(800)622-3278 or (716)874-4450
FAX: (716)874-4508

All prices, publication dates, and specifications are subject to change without notice.
Prices are in U.S. dollars. Payment in U.S. funds only.